THE CALM
COLORING BOOK

THE CALM

COLORING BOOK

Beautiful images to soothe your cares away

CHARTWELL
BOOKS

This edition printed in 2015 by
CHARTWELL BOOKS
an imprint of Book Sales
a division of Quarto Publishing Group USA Inc.
142 West 36th Street, 4th Floor
New York, New York 10018

Copyright © Arcturus Holdings Limited
26/27 Bickels Yard, 151–153 Bermondsey Street,
London SE1 3HA

ISBN: 978-0-7858-3288-1
AD004596NT

Printed in China
Reprinted 2015 (three times).

Introduction

It's official – coloring is good for you! Whatever your age, shading a picture in colors of your choice generates a sense of stillness and wellness. It also stimulates brain areas related to motor skills and creativity. Coloring works as a relaxation technique – calming the mind and occupying the hands – and helps you enter a freer state of being.

The Calm Coloring Book contains gorgeous images of birds, leaves, flowers, fish, butterflies and tranquil landscapes to soothe the mind and please the senses. By coloring in the outlines you will de-stress your mind and body and create your own beautiful artwork. So put your worries on hold, pick up your crayons, pencils or felt-tips, and get ready to unleash your creative side…

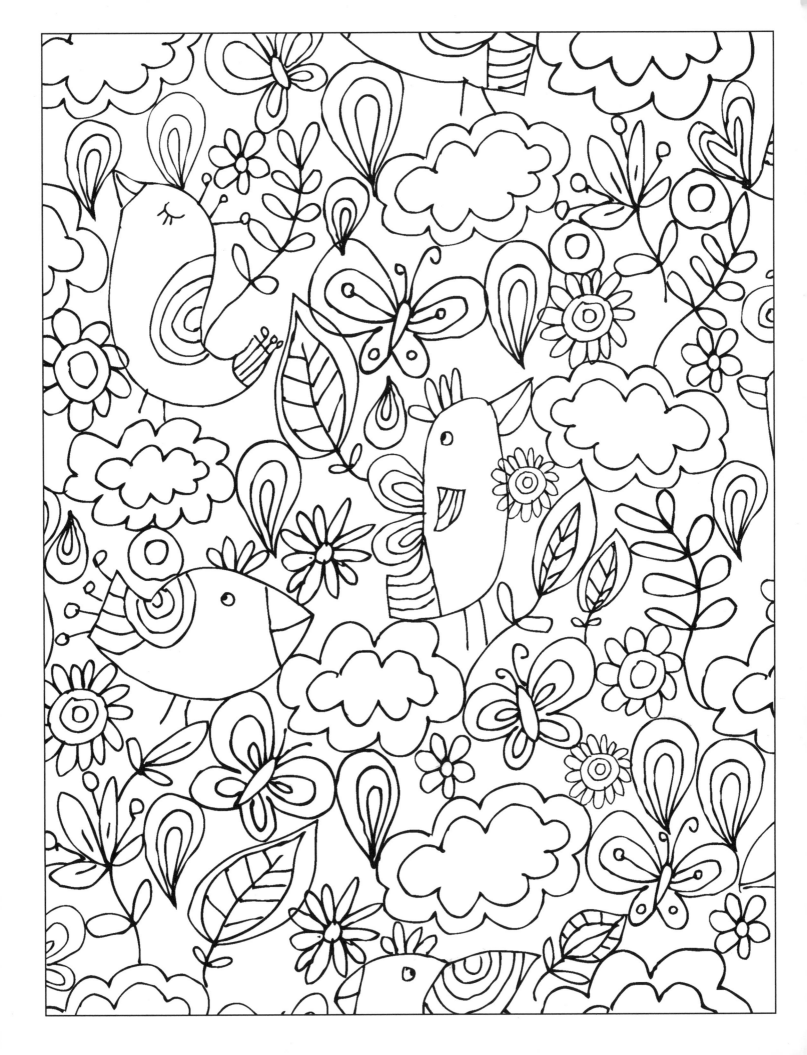

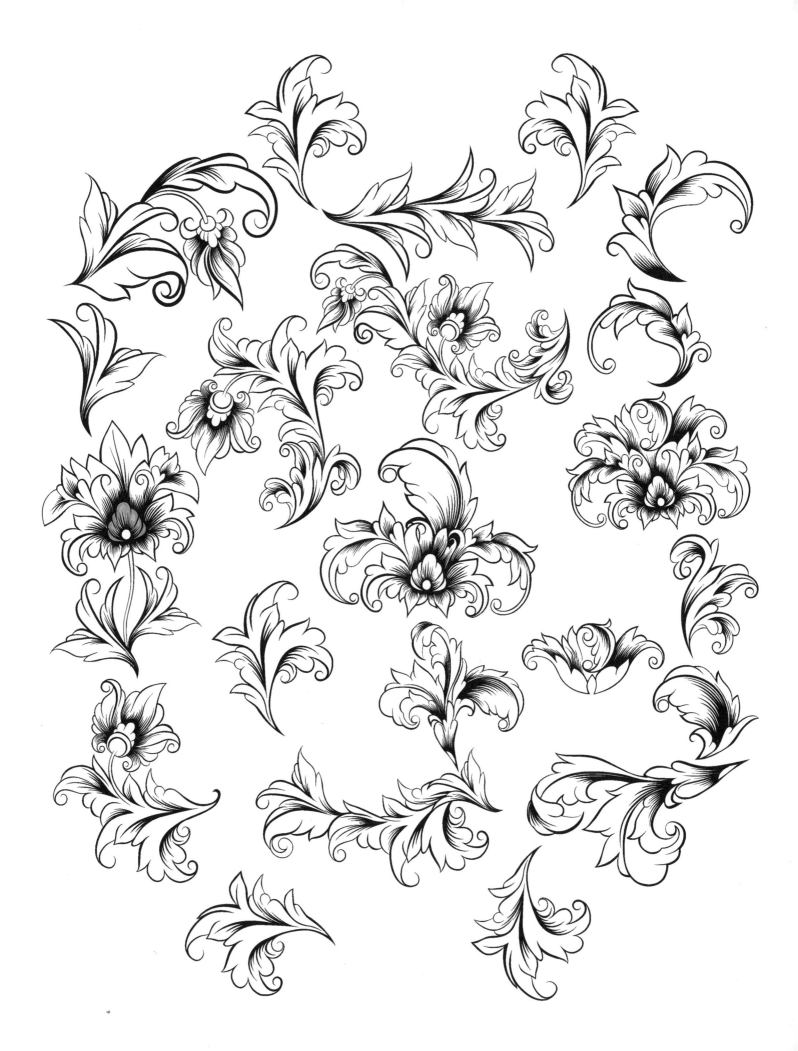

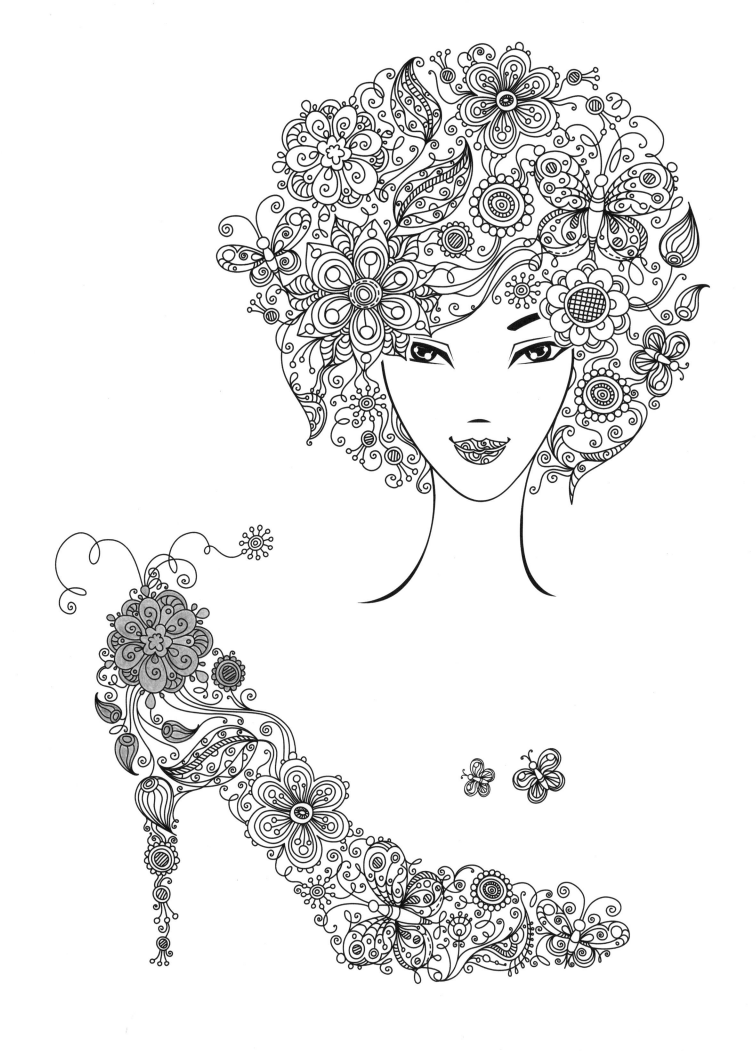

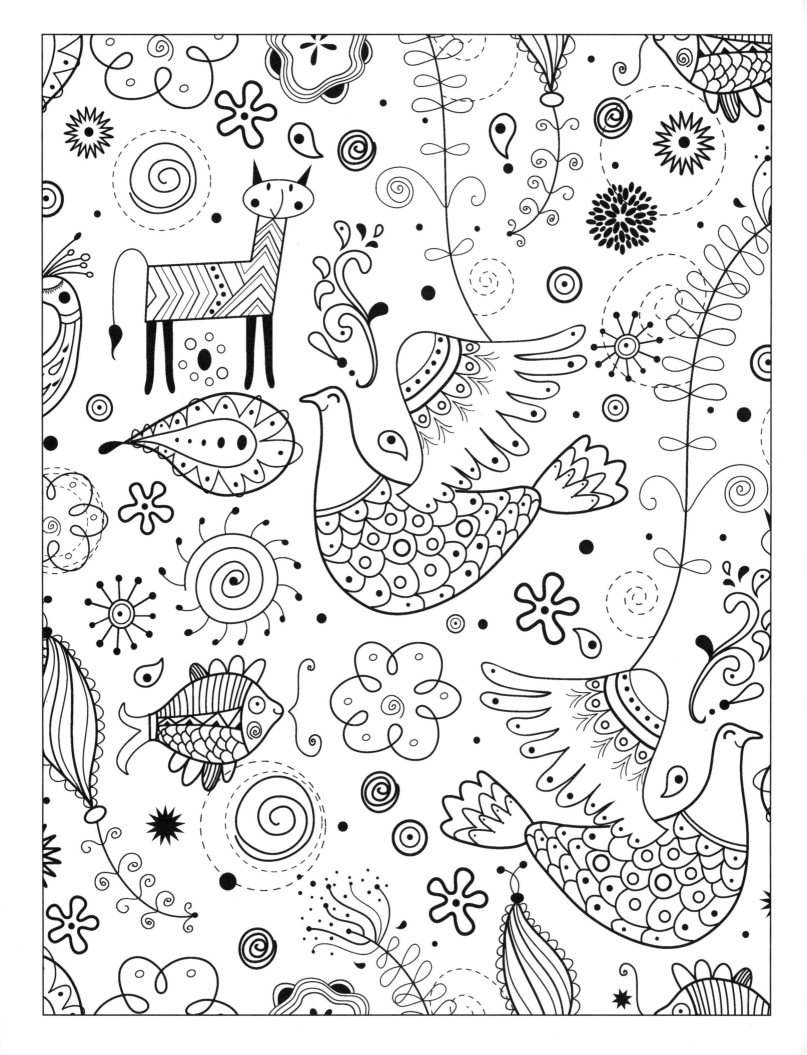

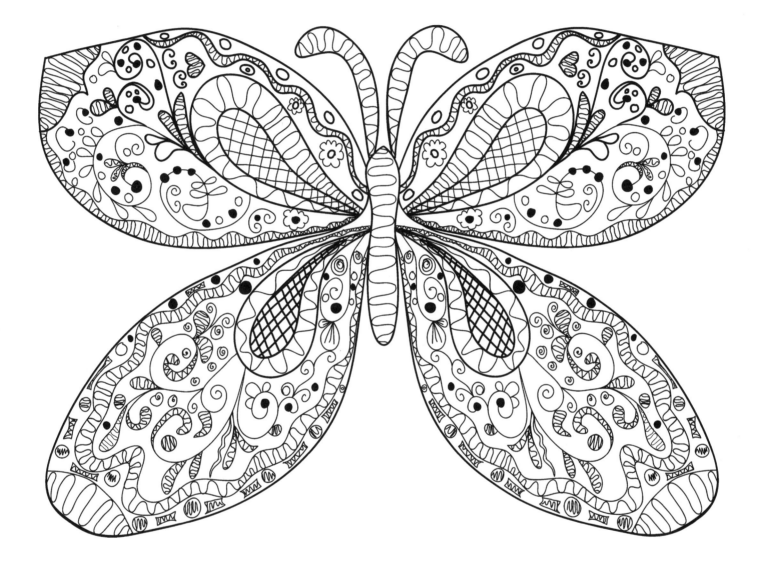

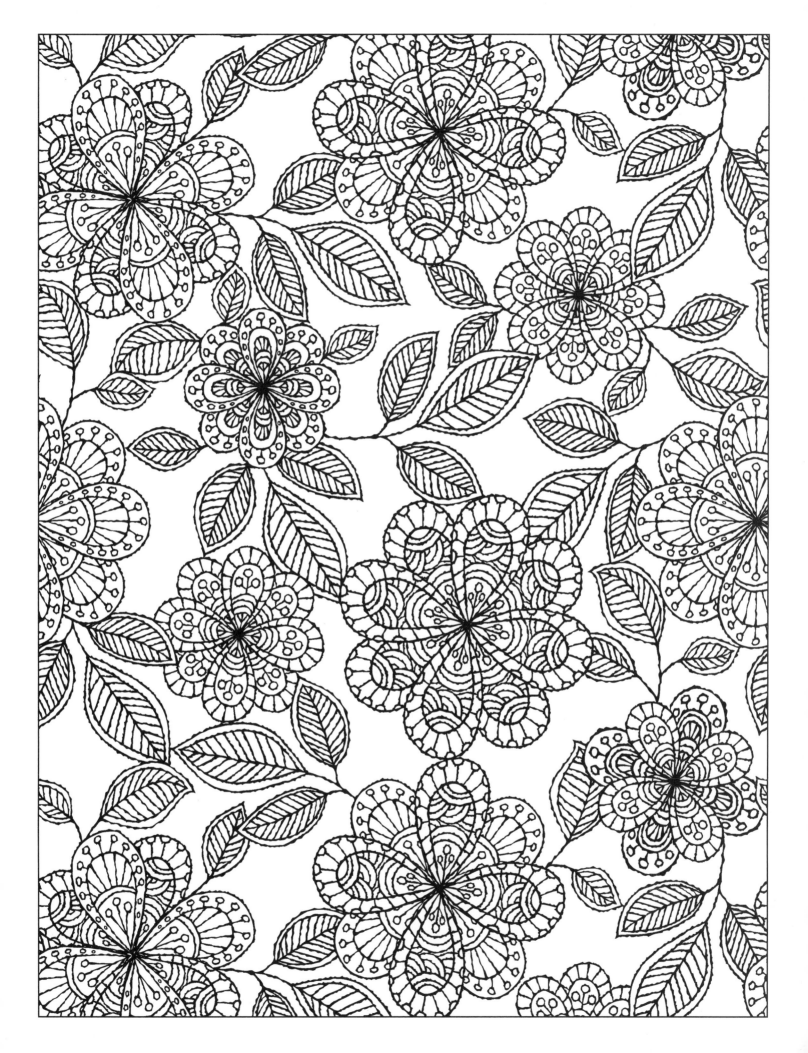

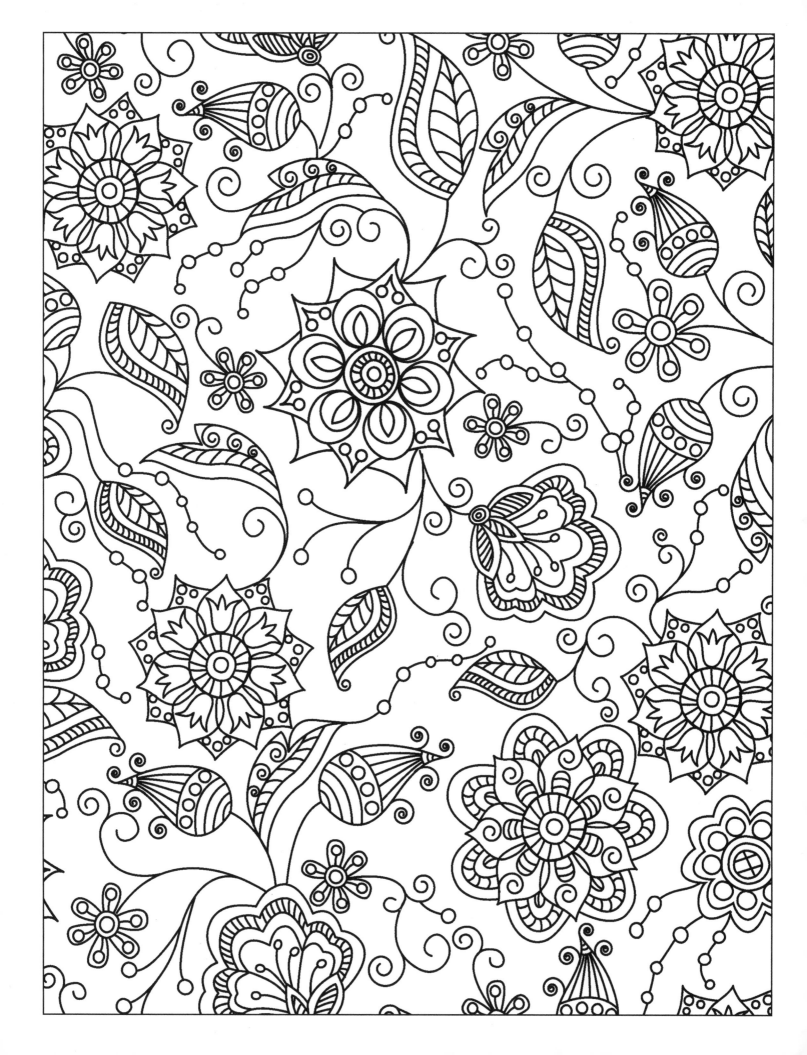

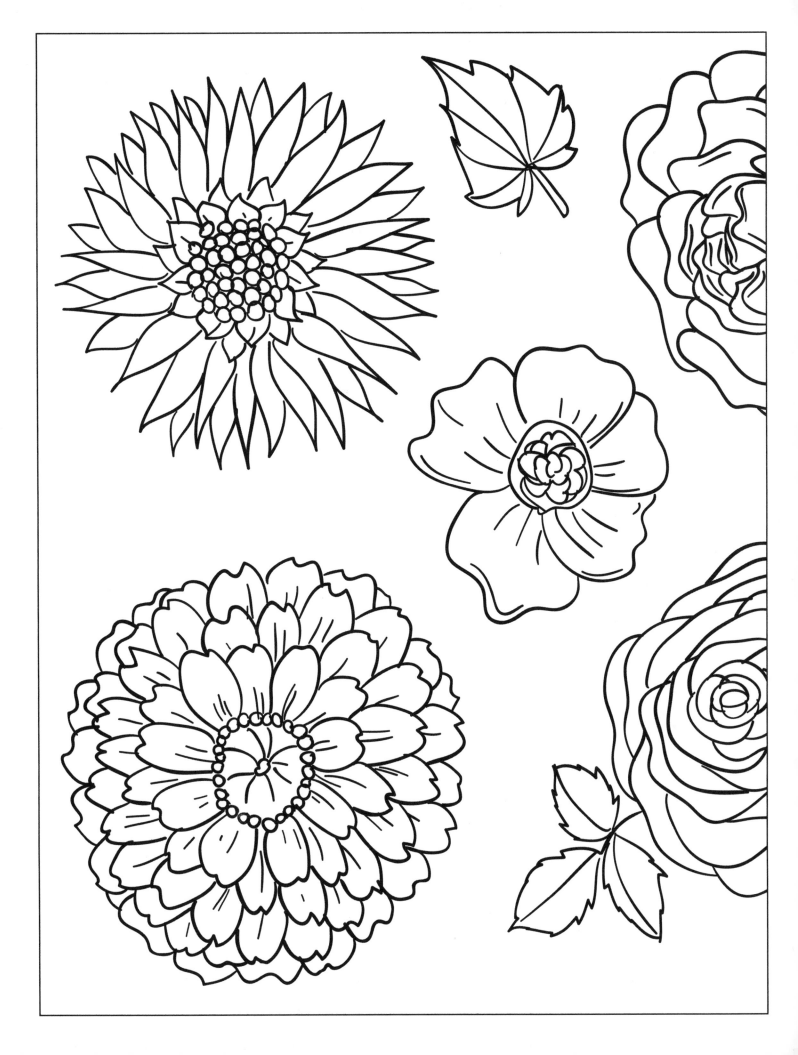

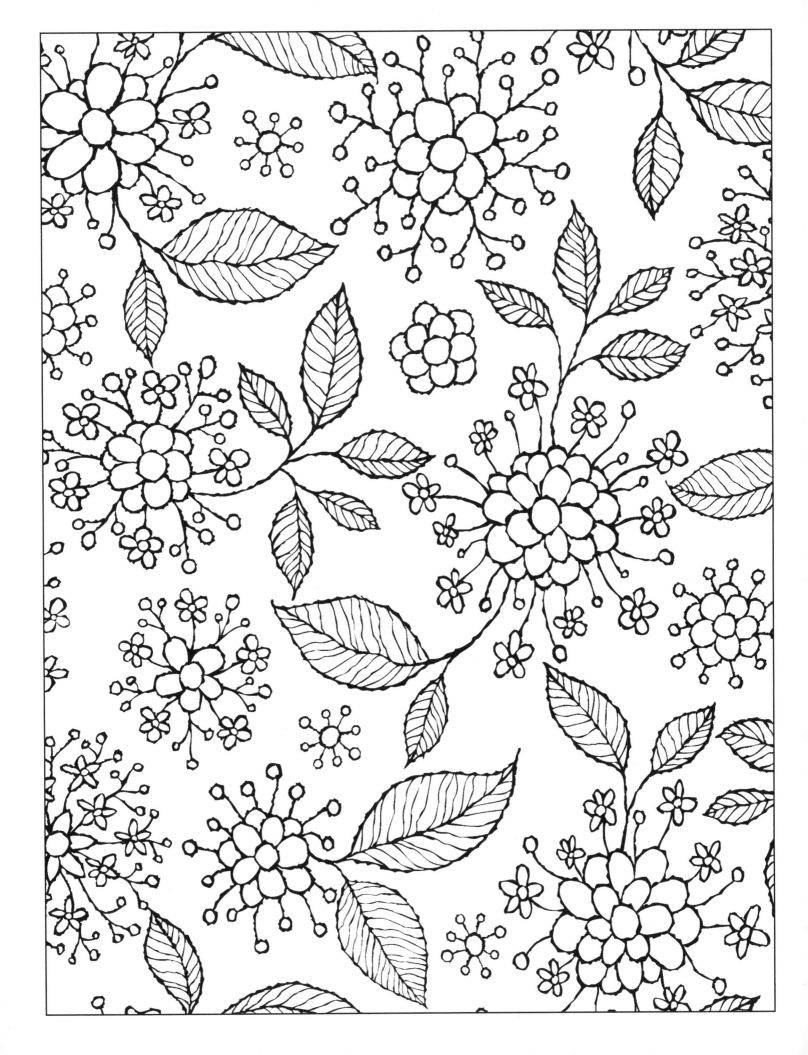

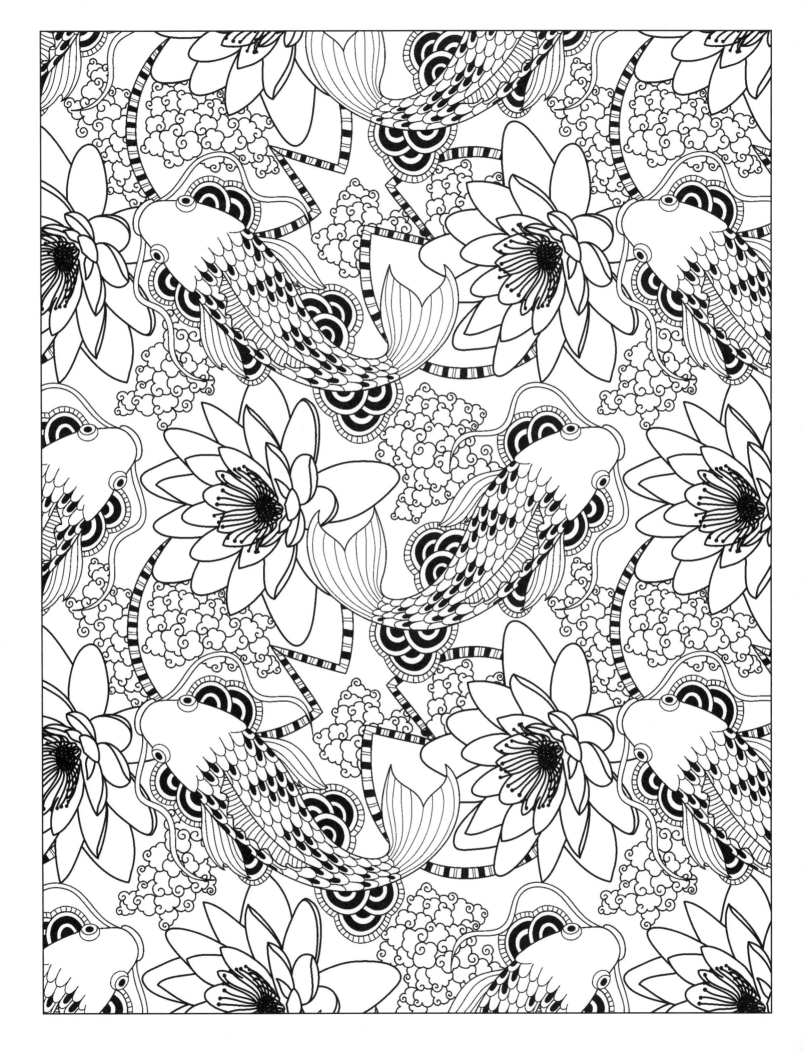

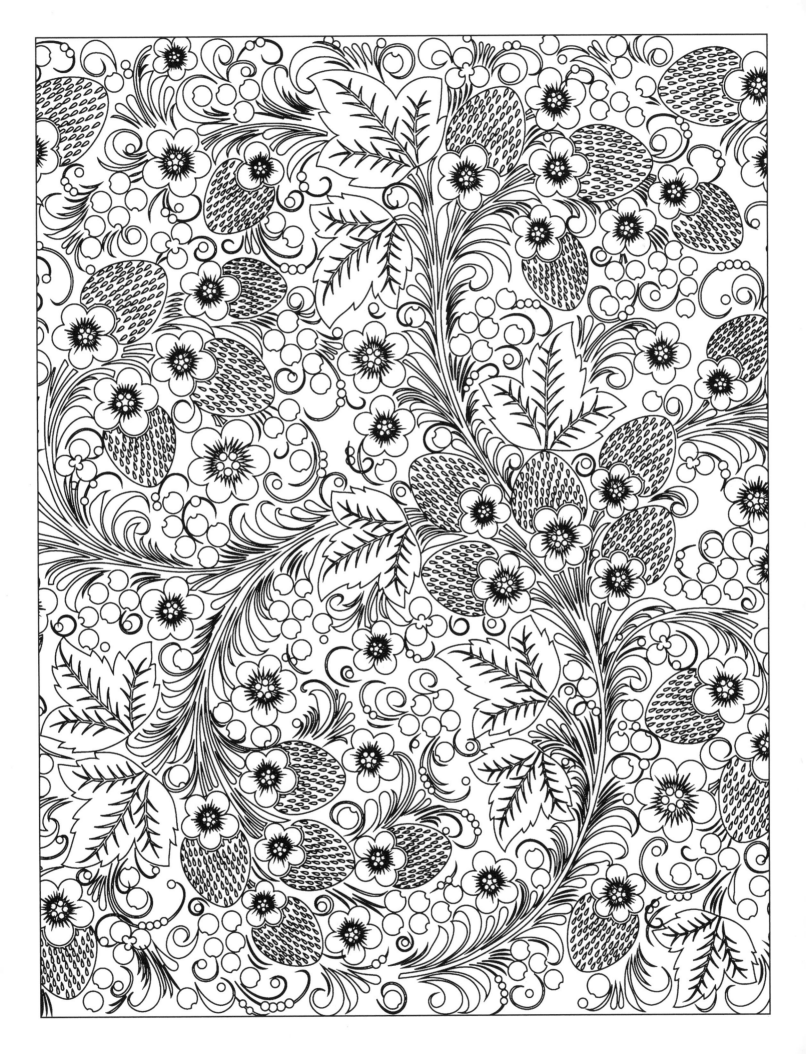

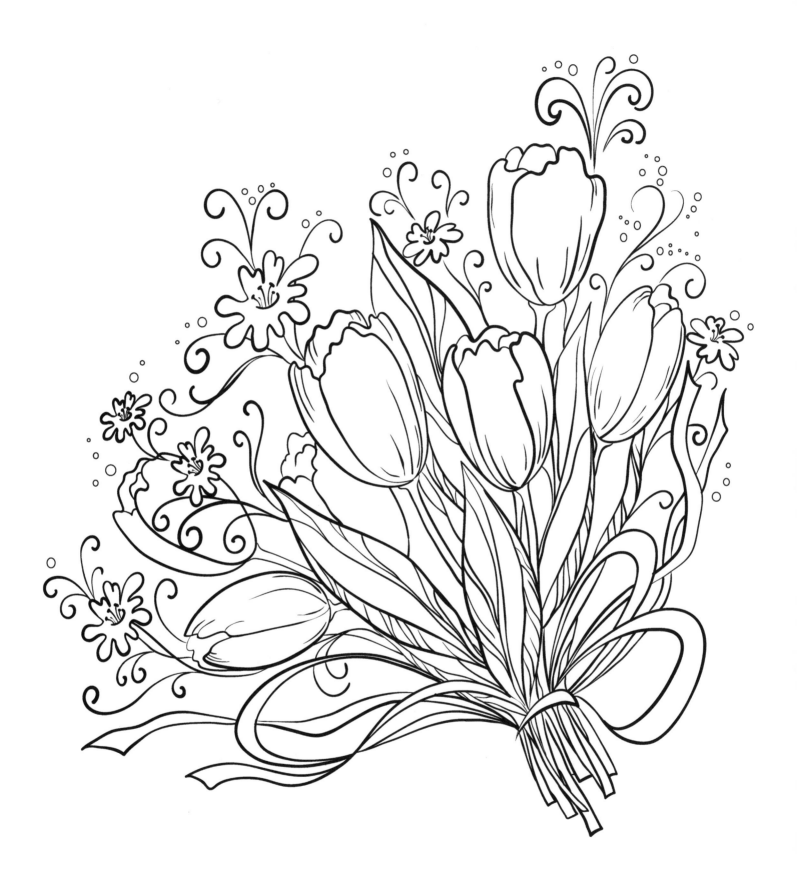

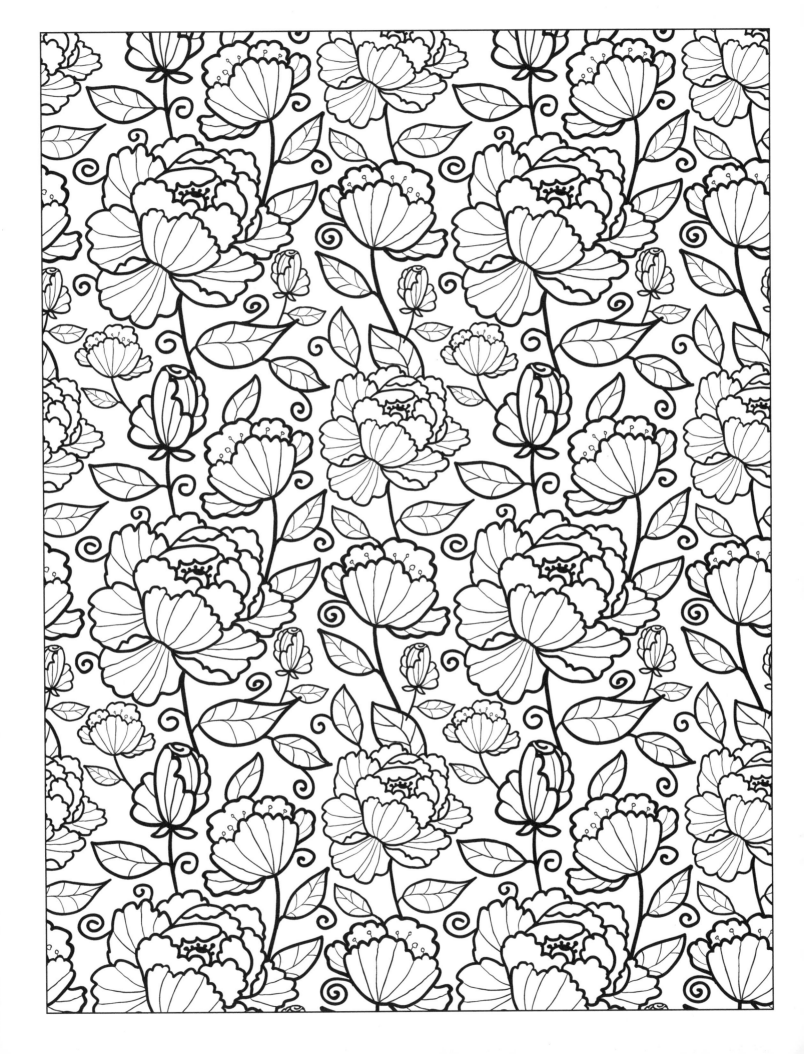

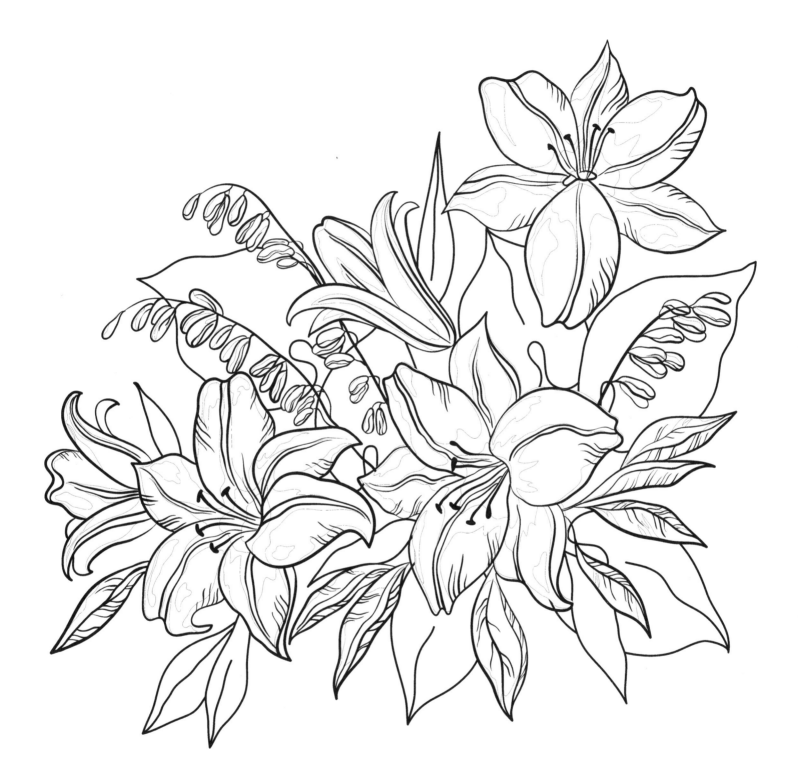

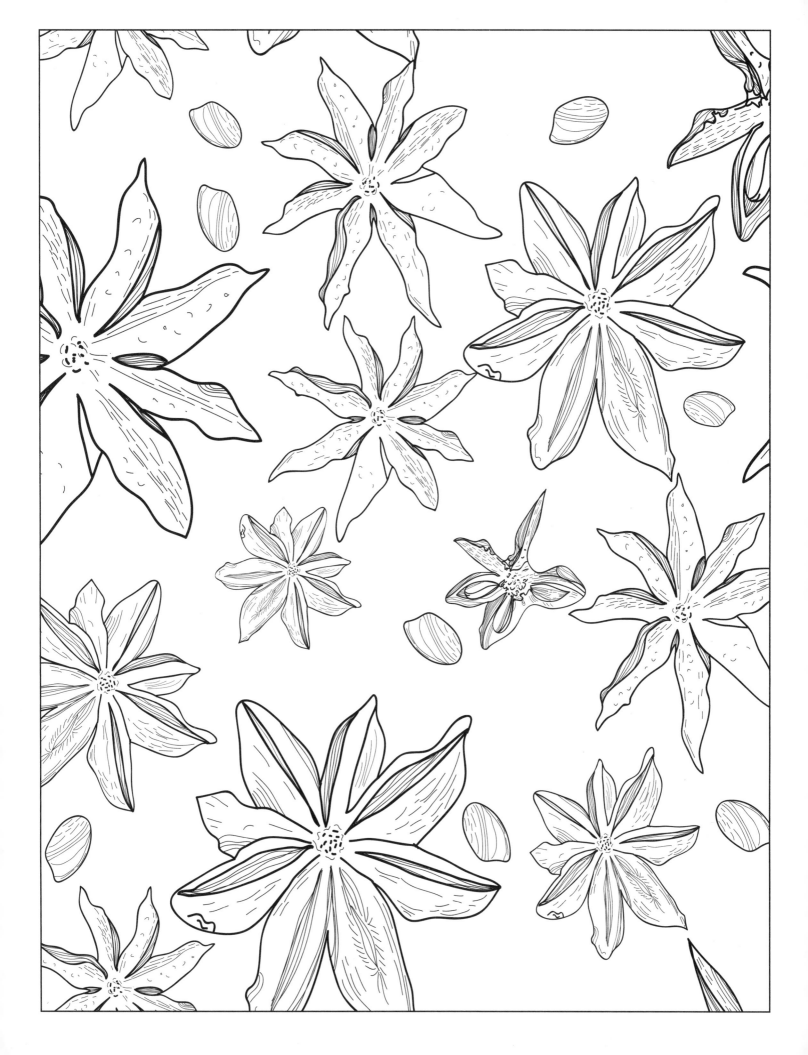

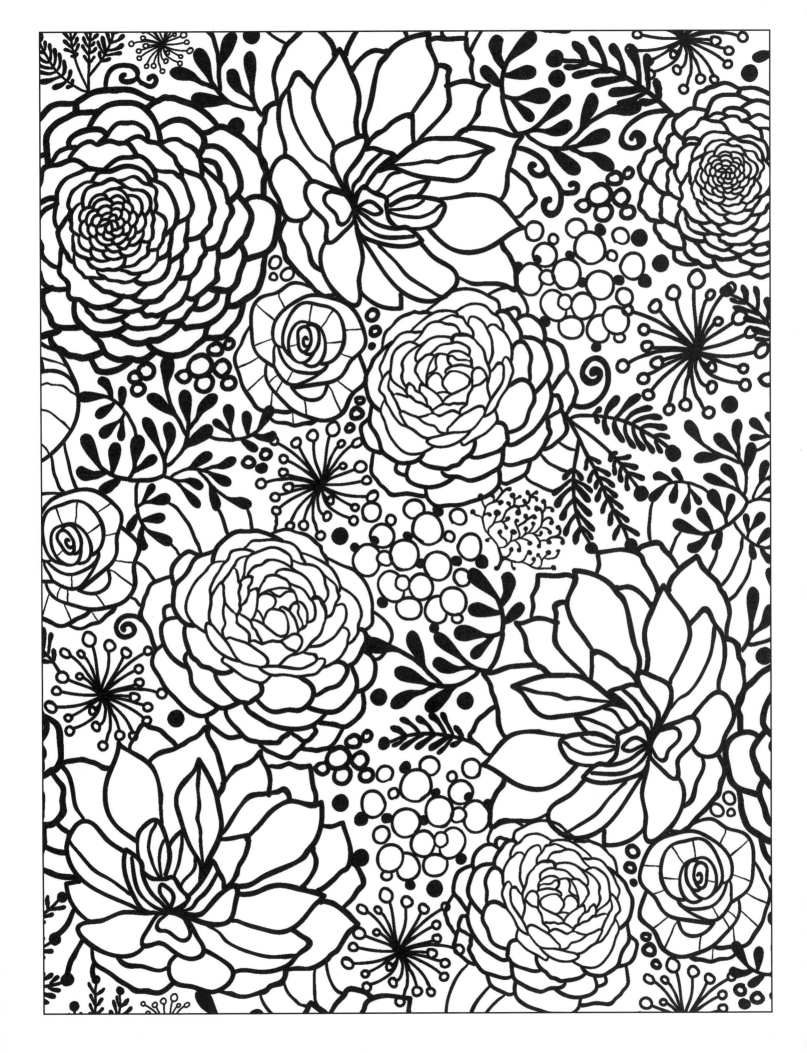

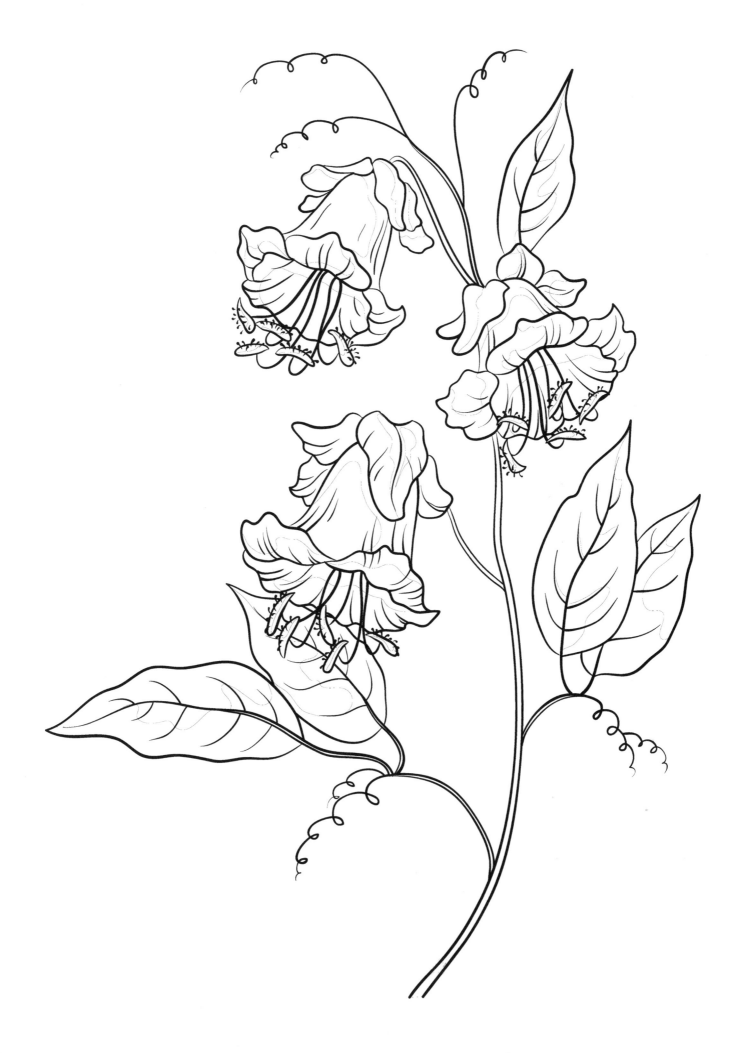

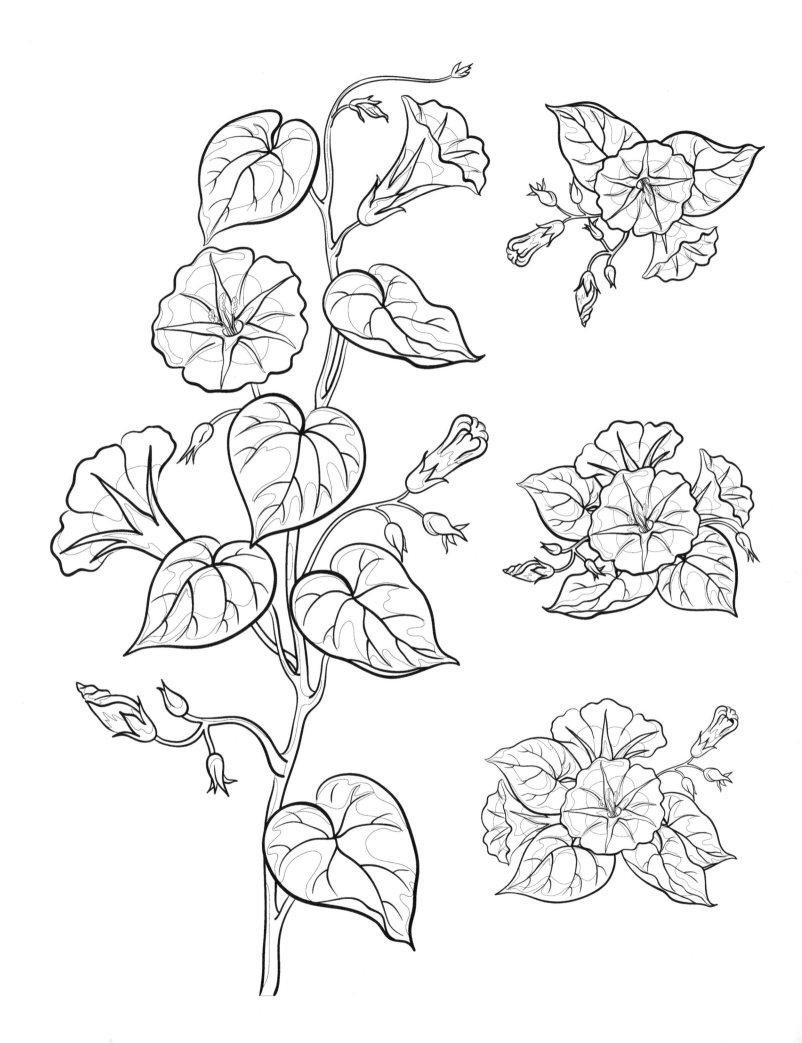

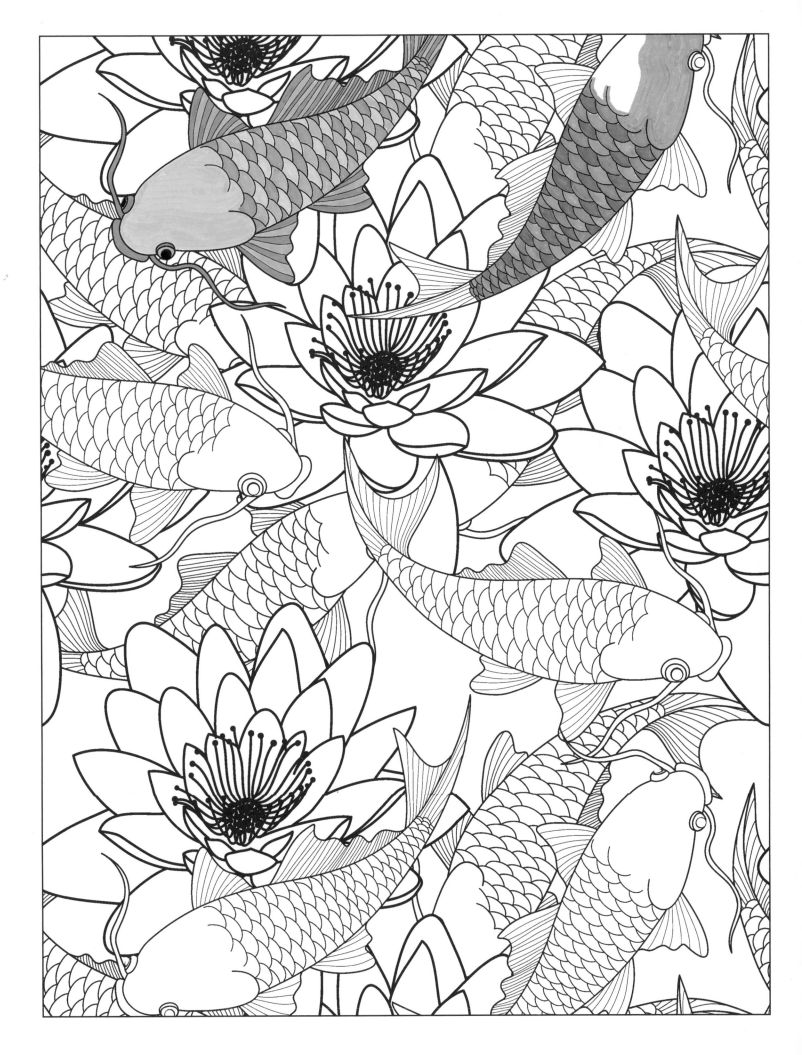

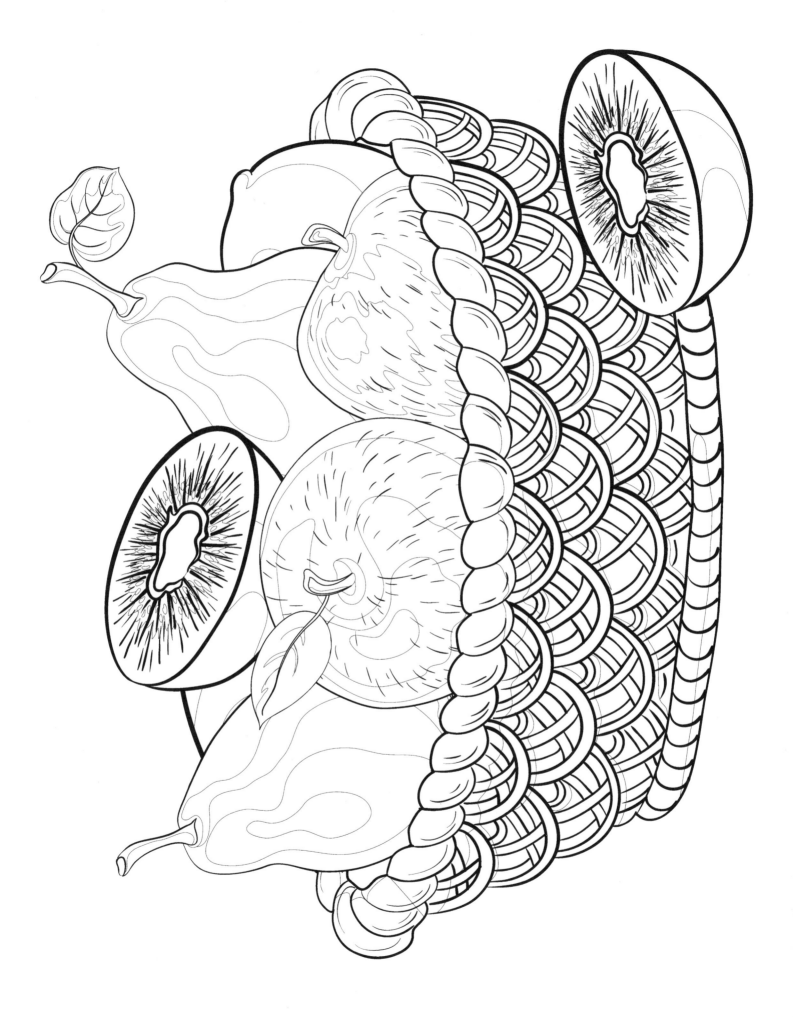

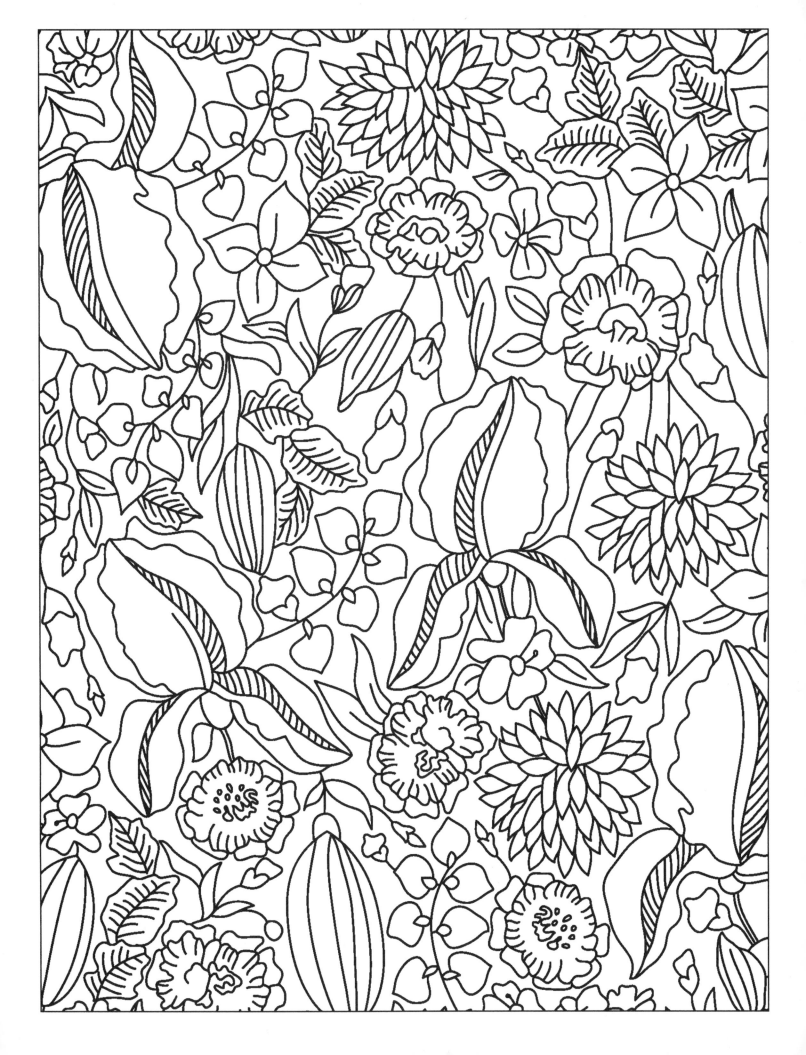

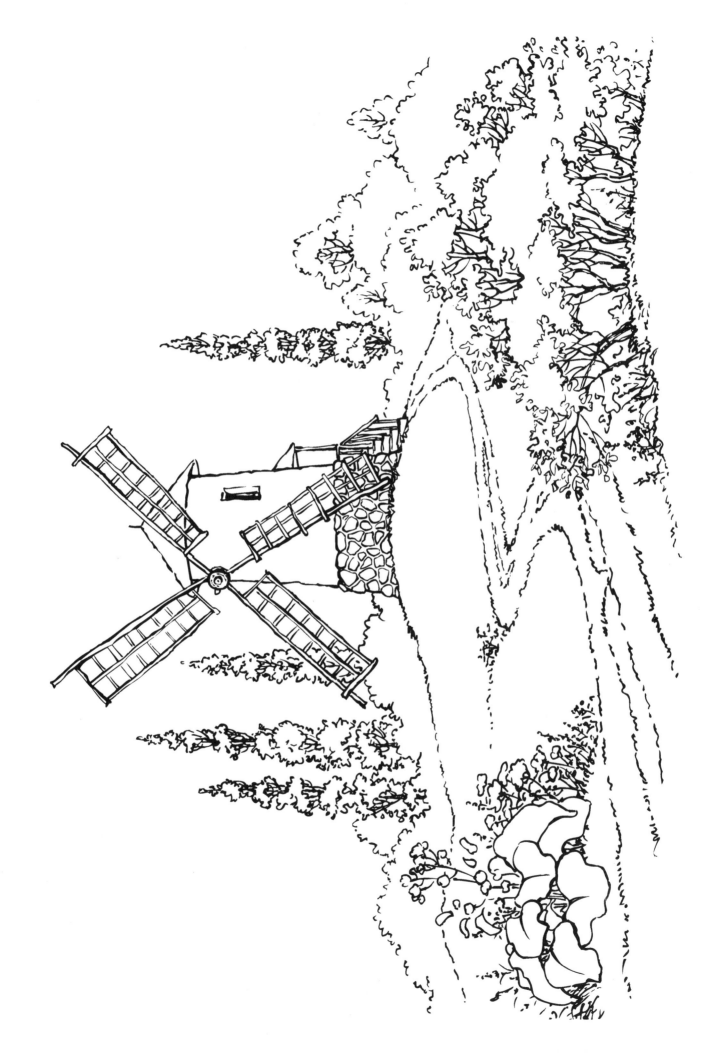

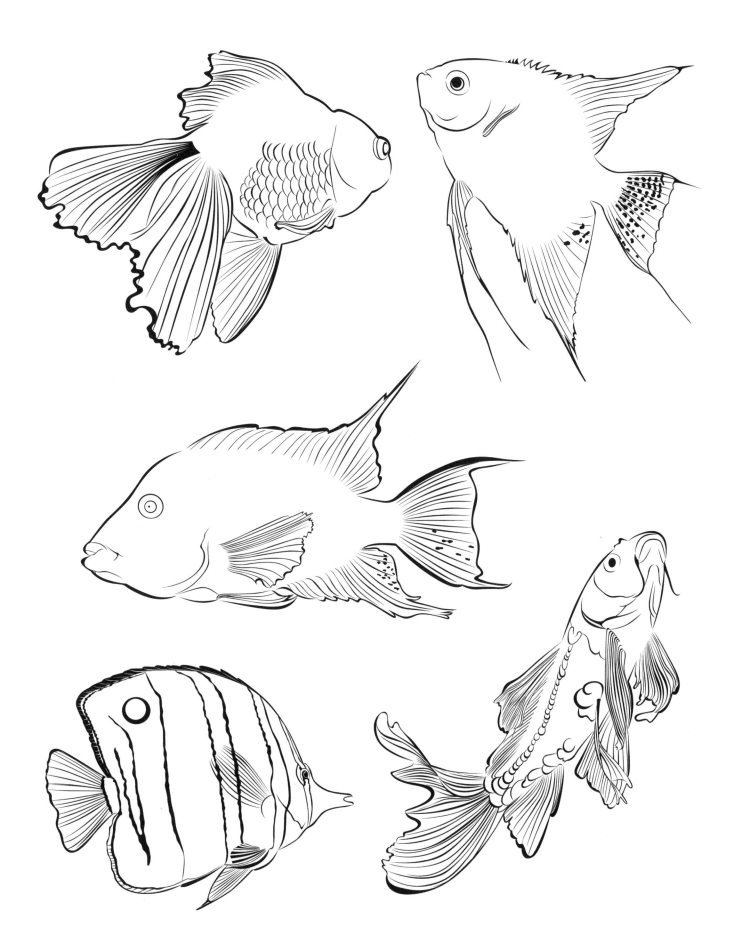

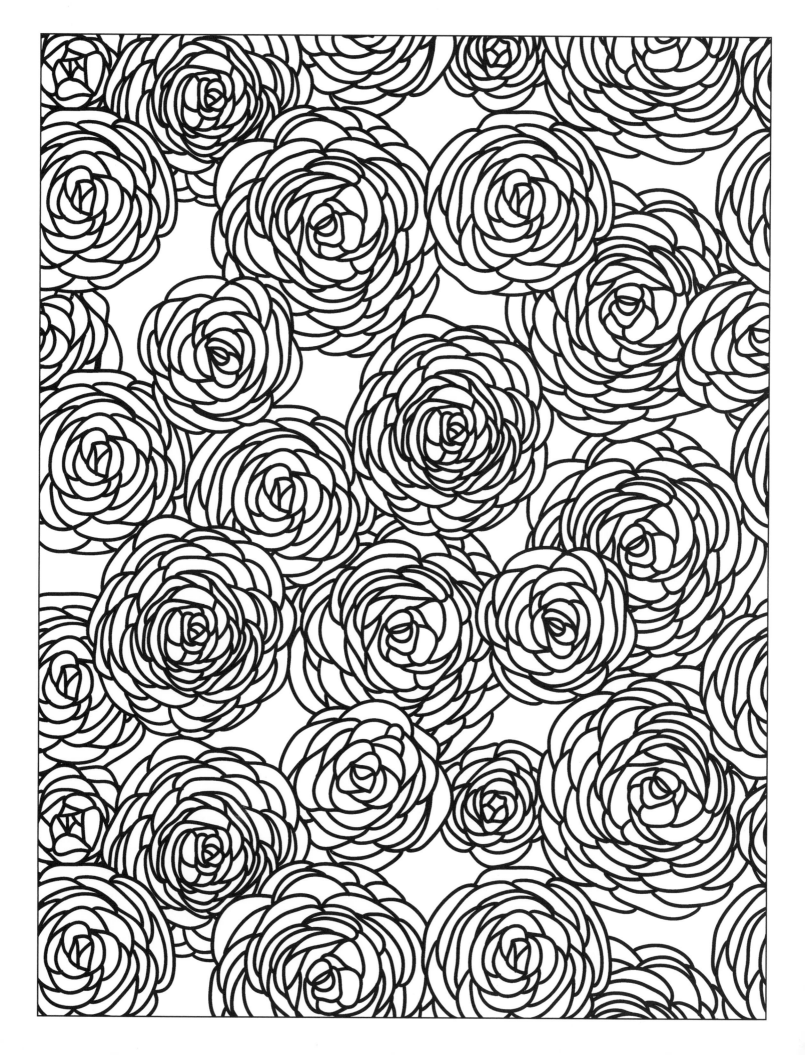

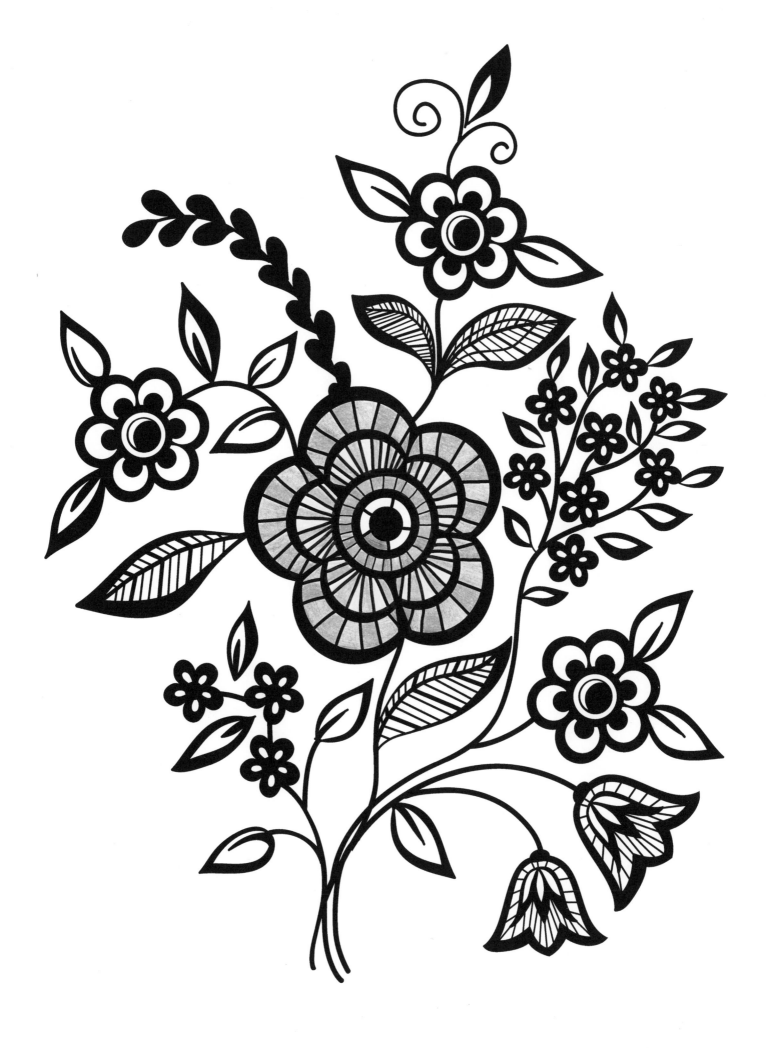

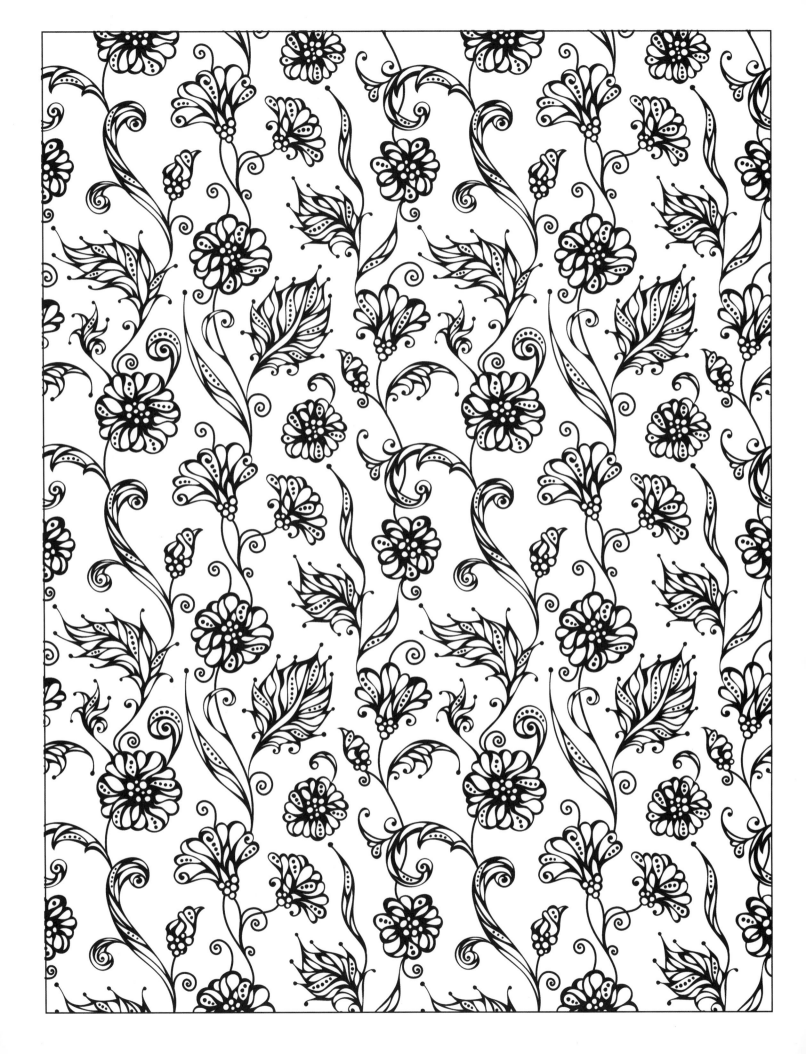

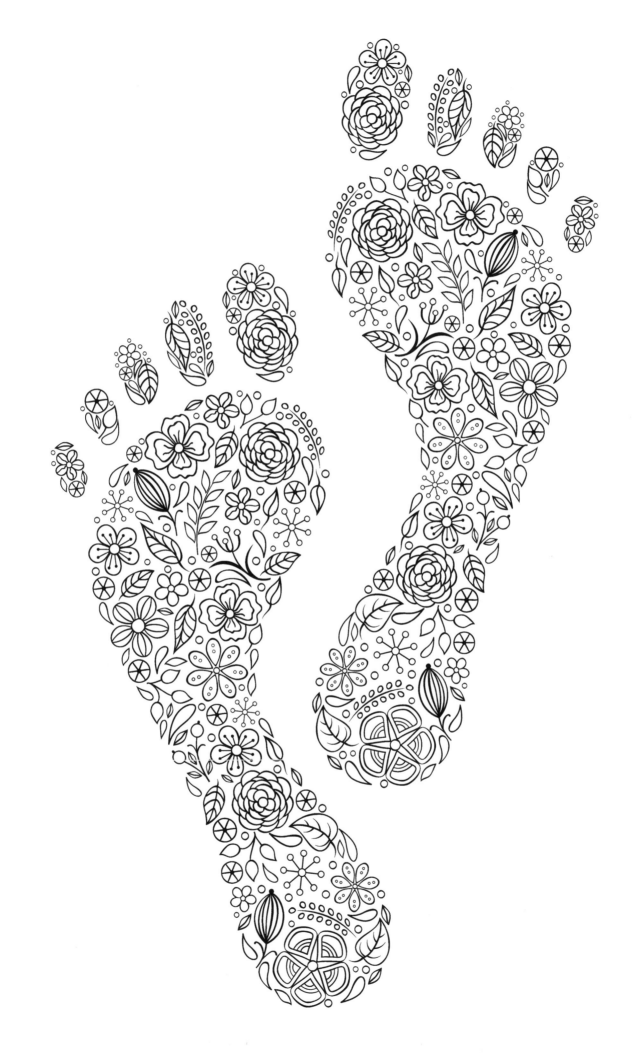

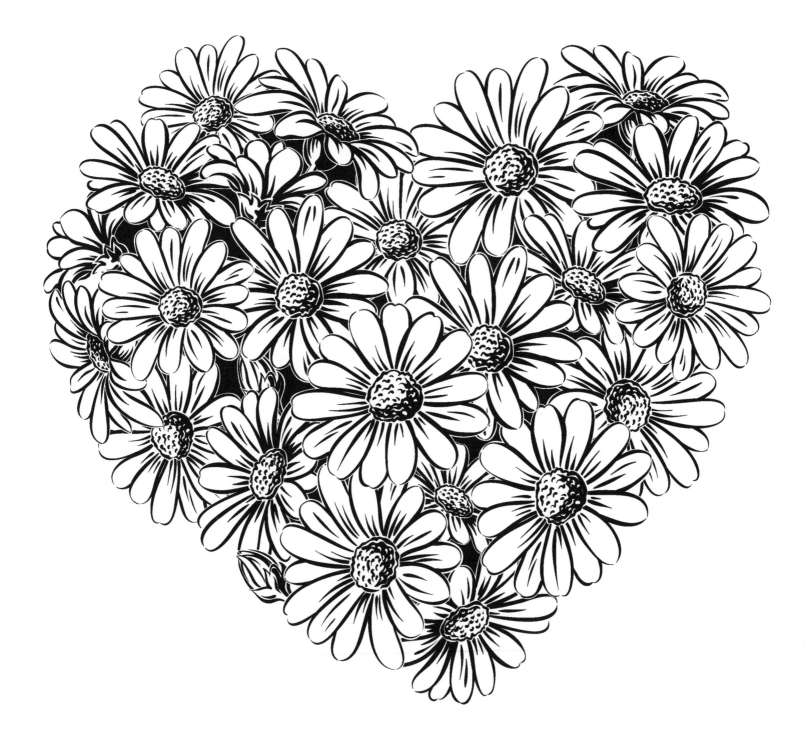

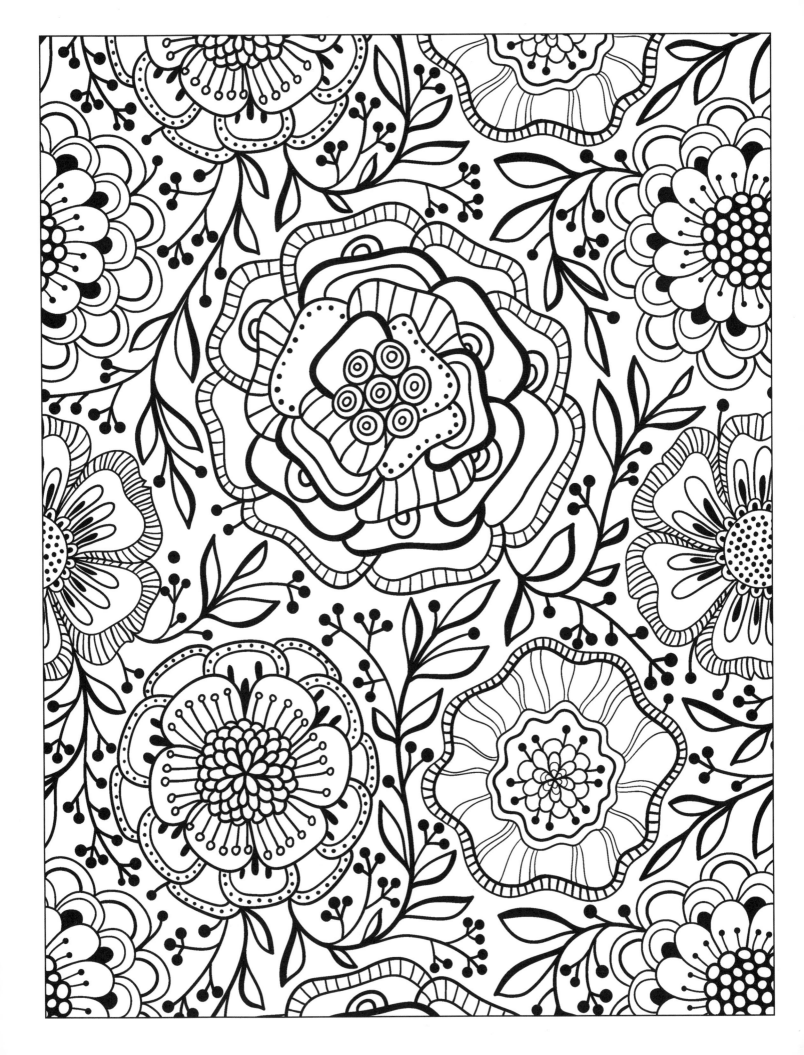

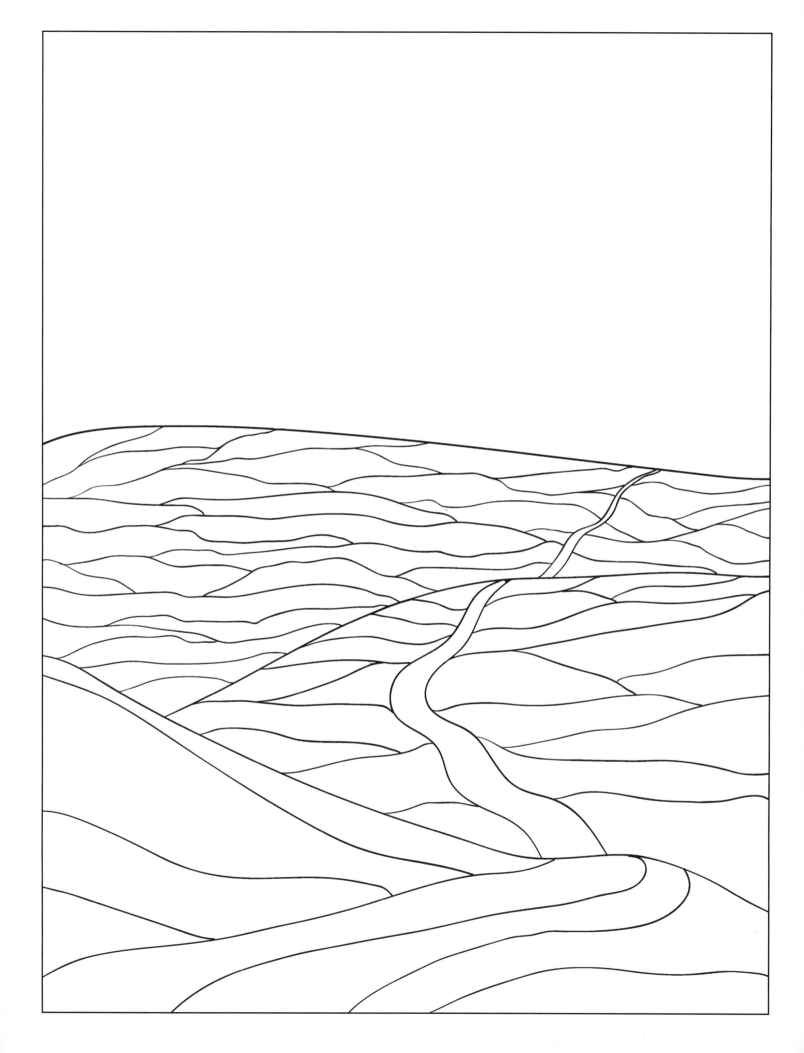

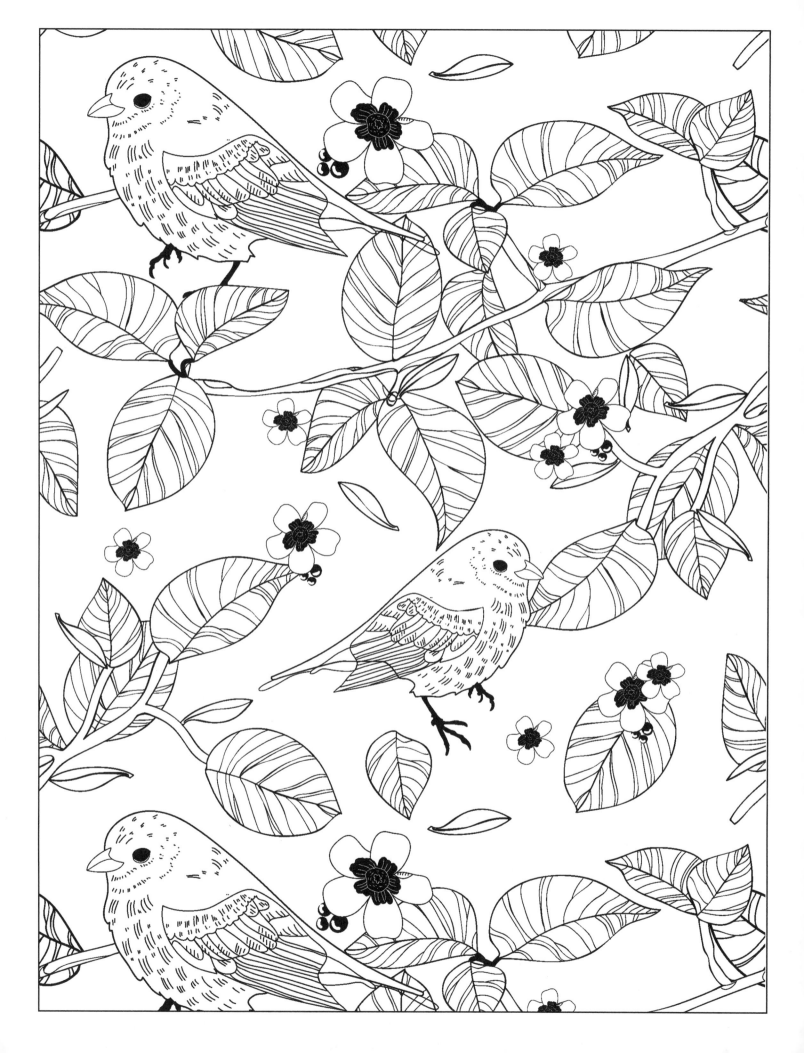

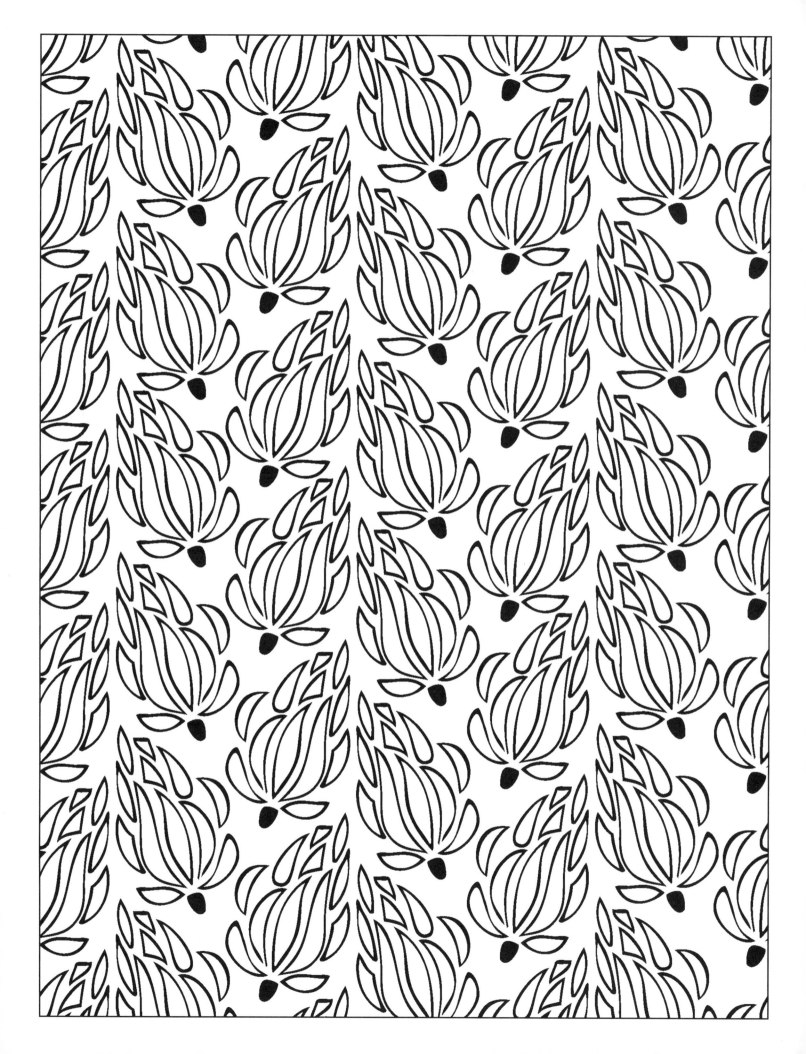

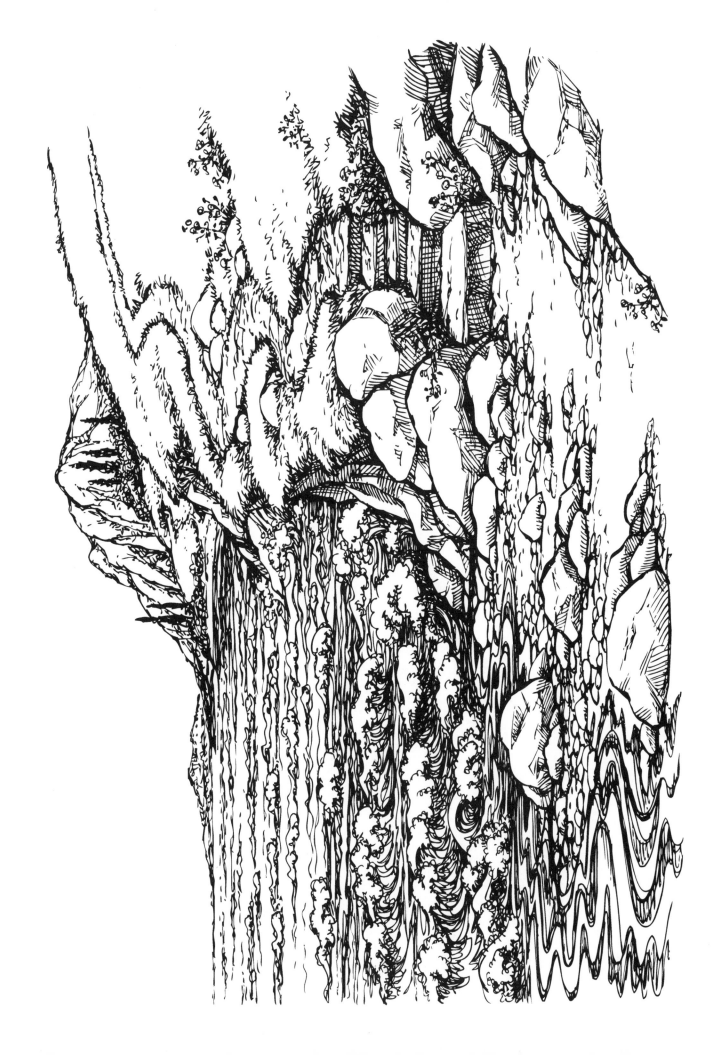

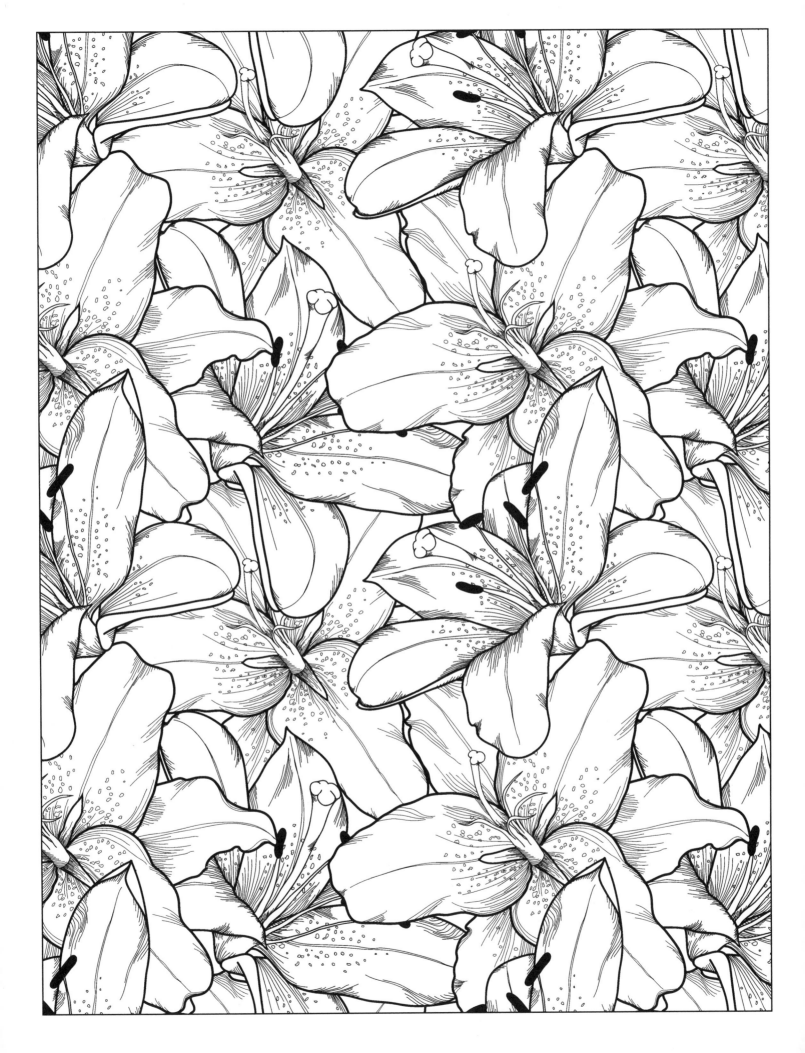

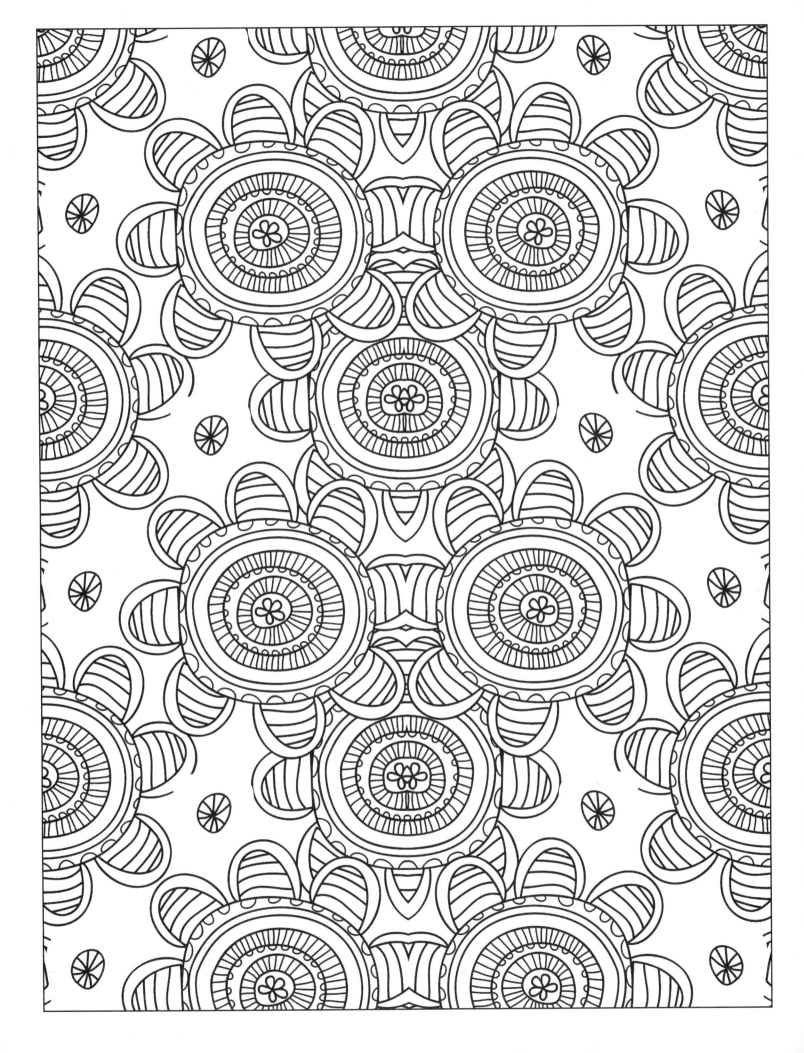

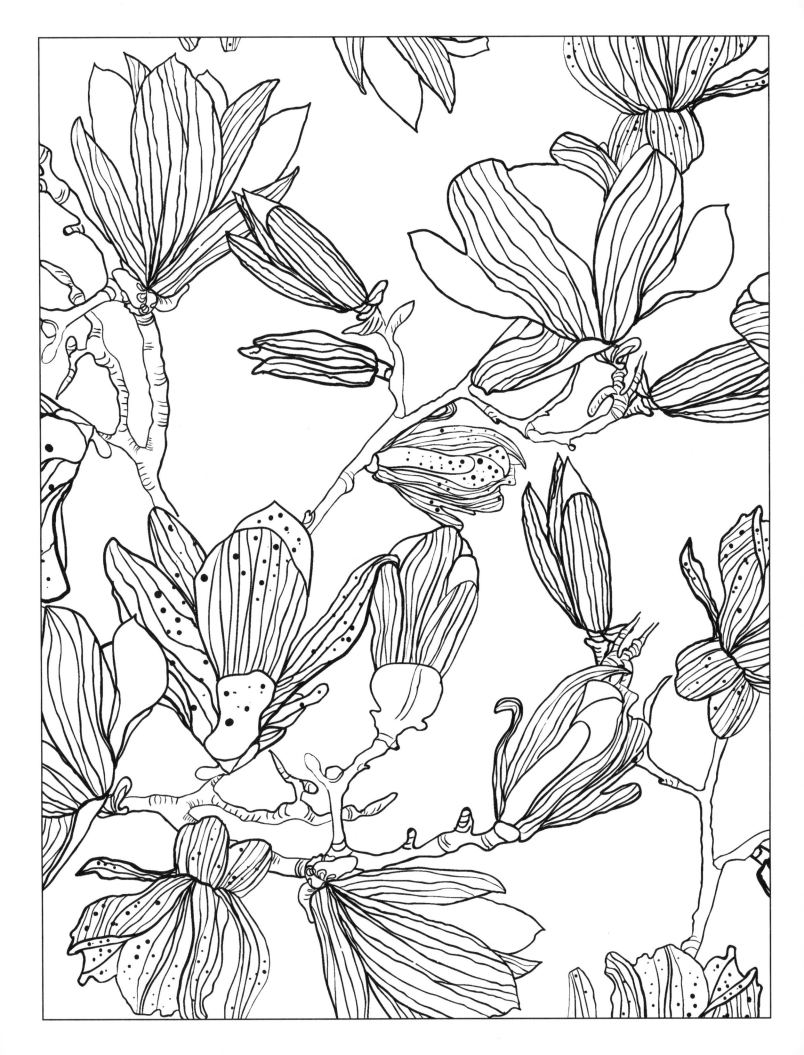

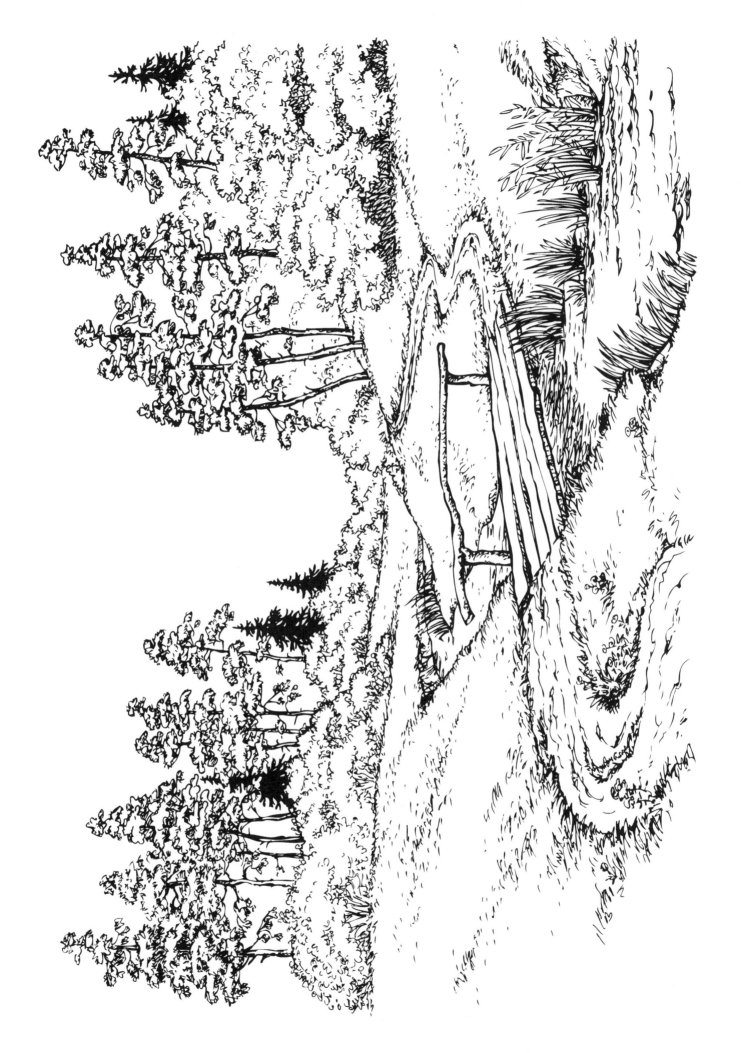

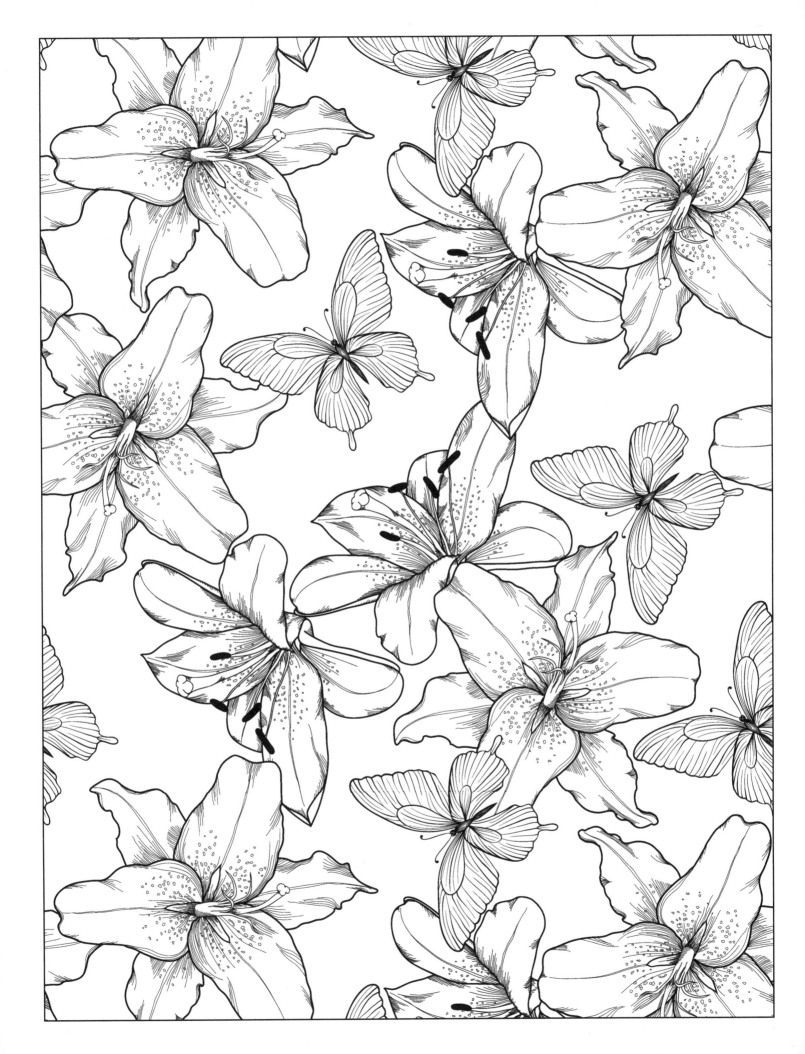

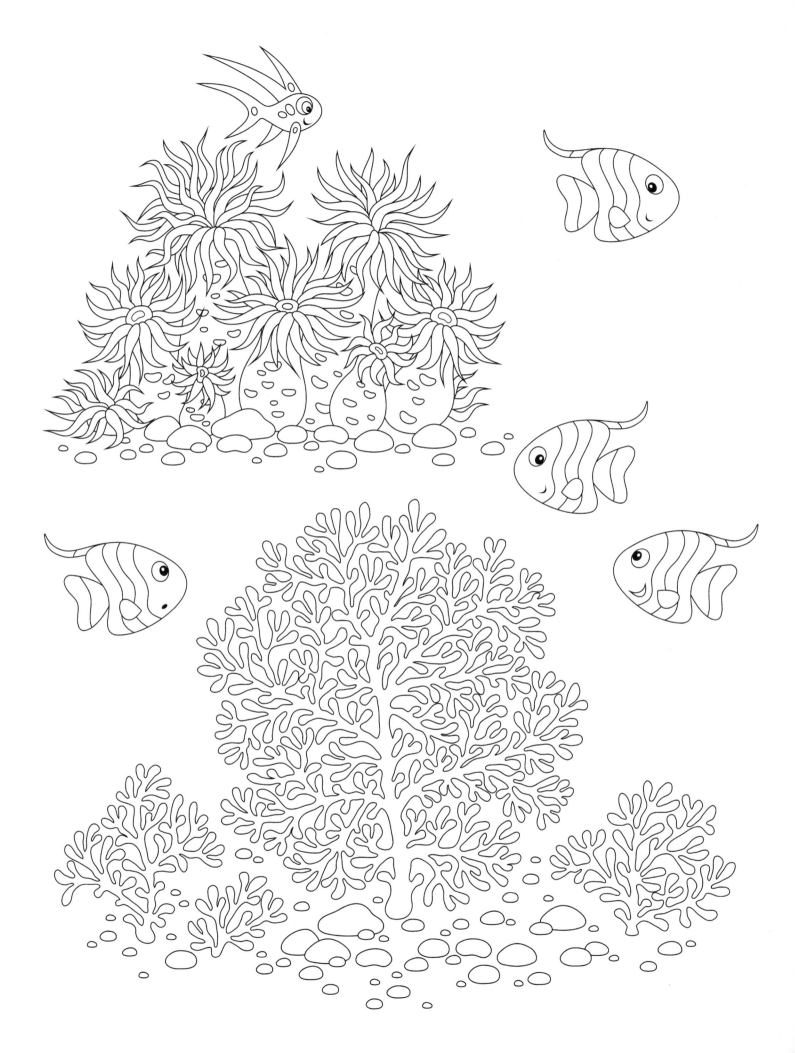

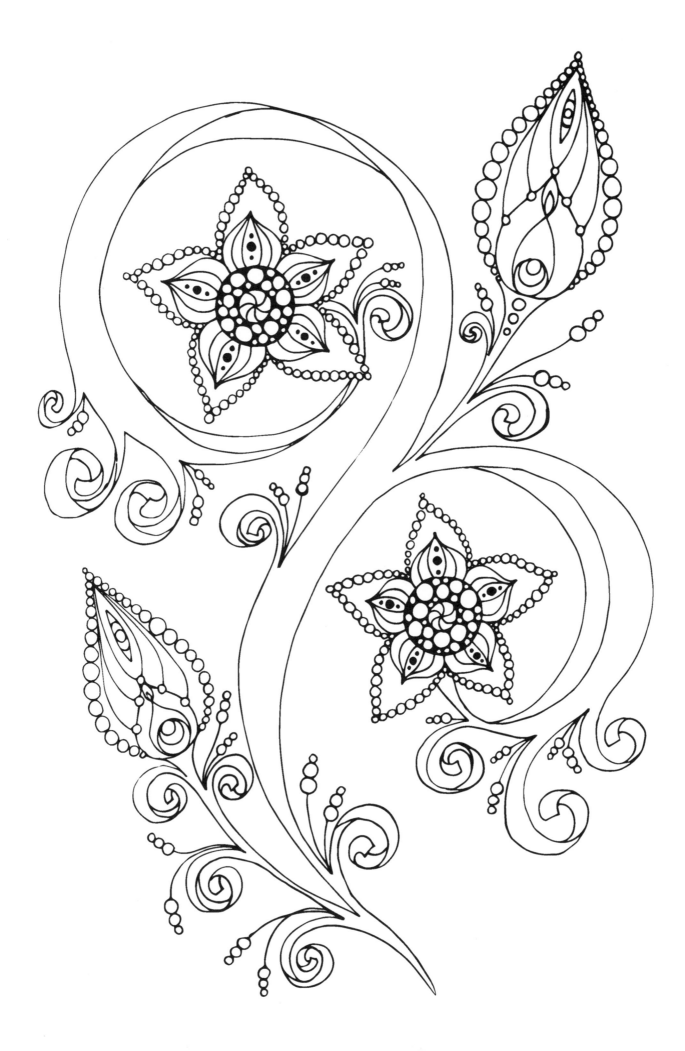

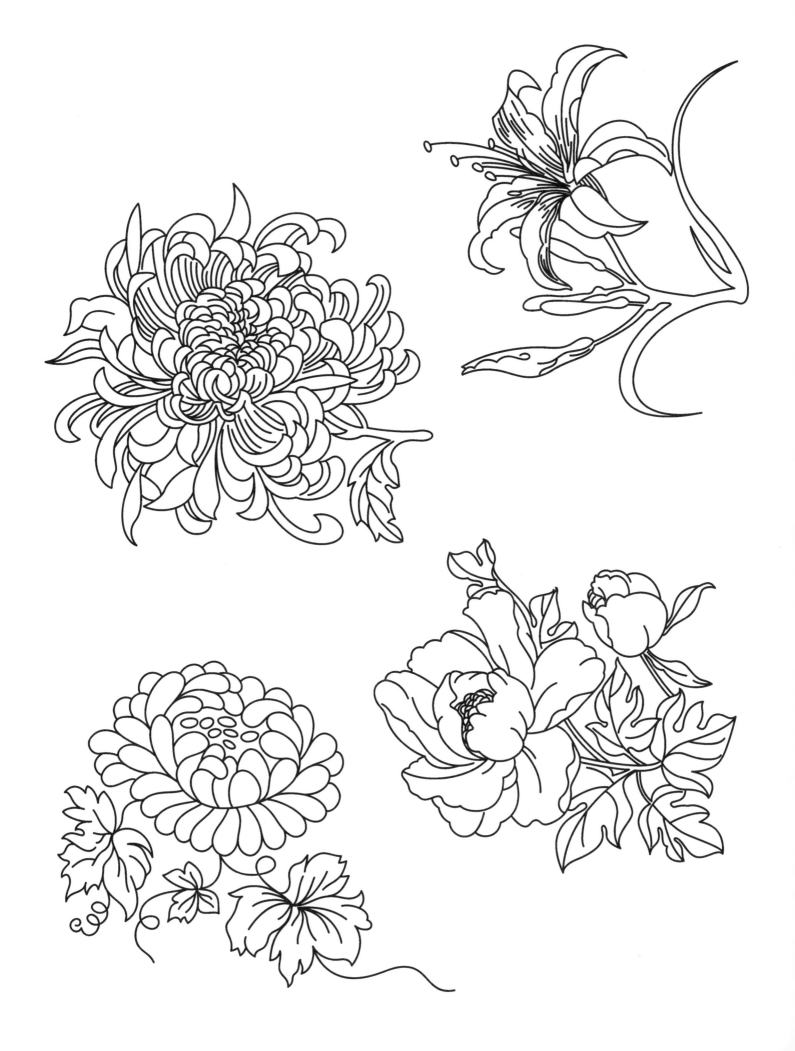

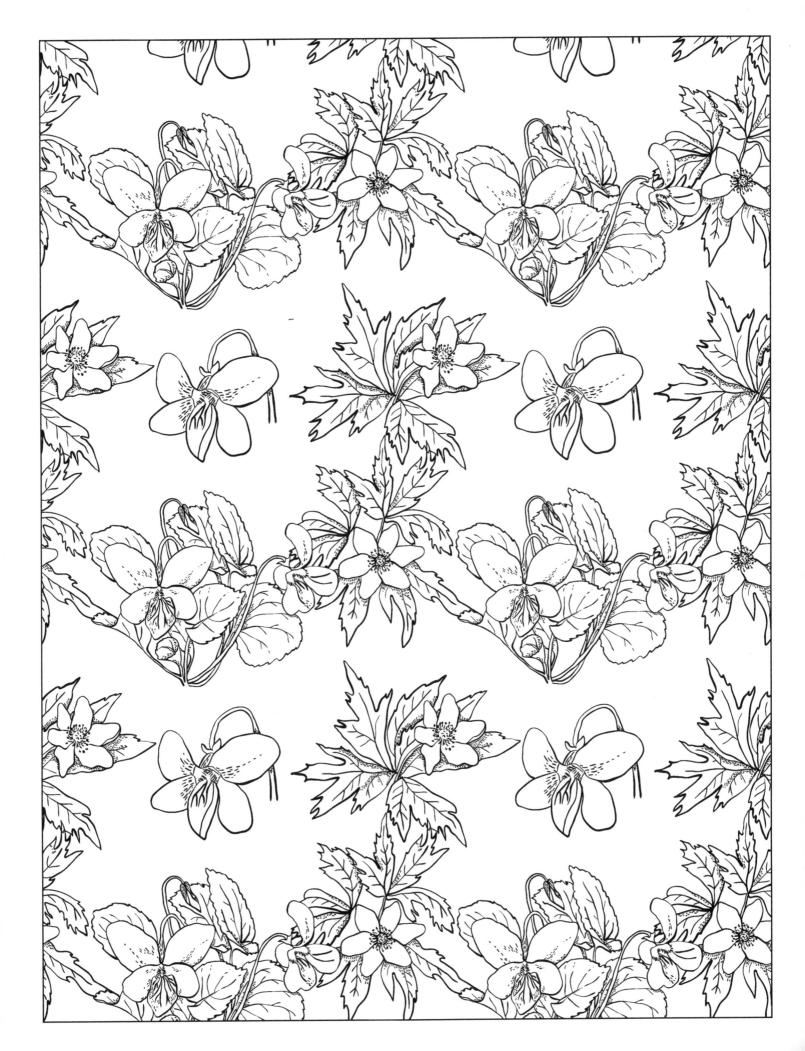

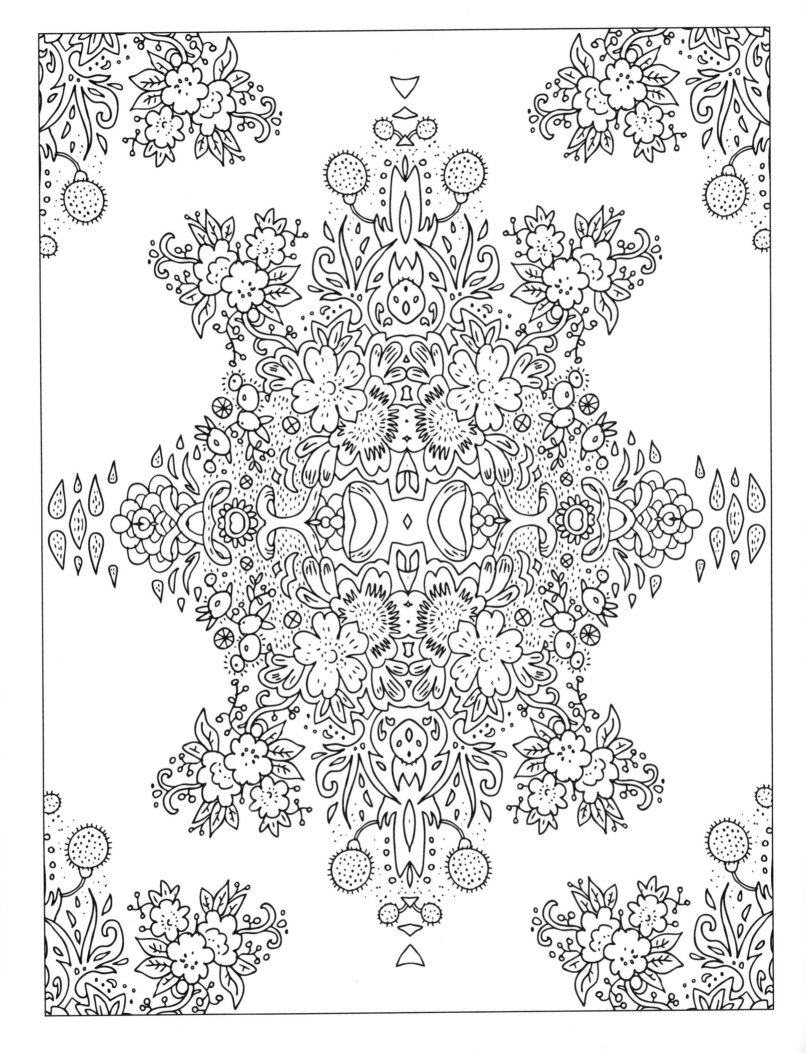

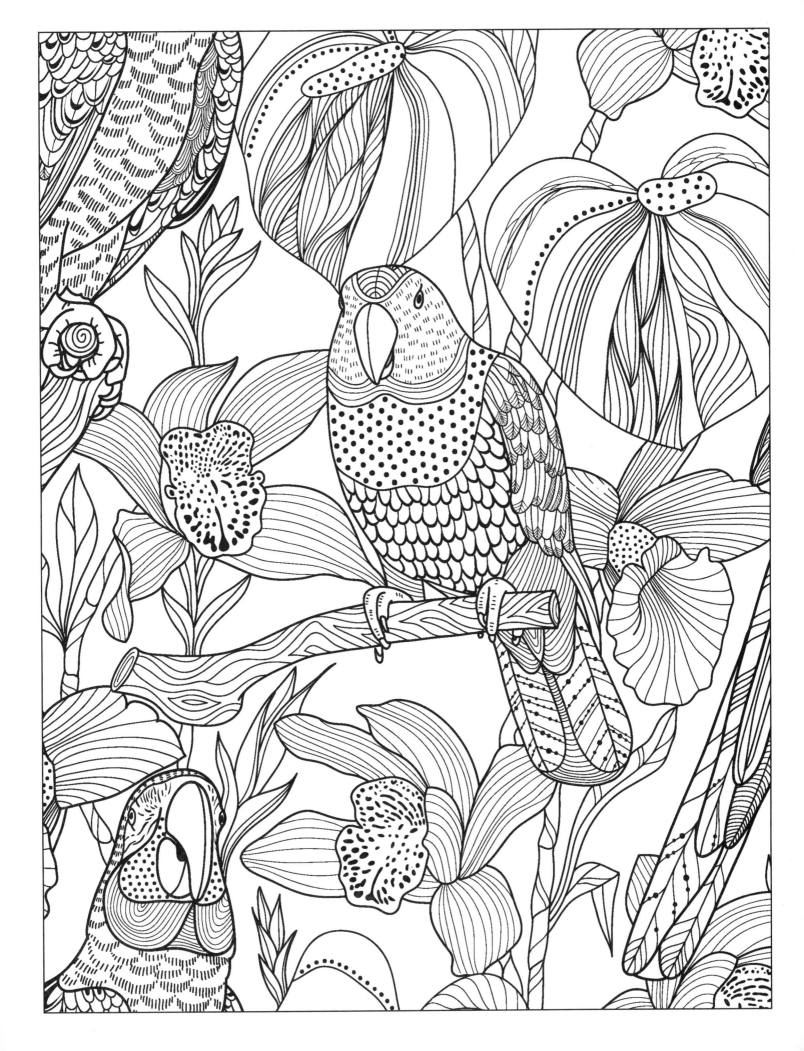

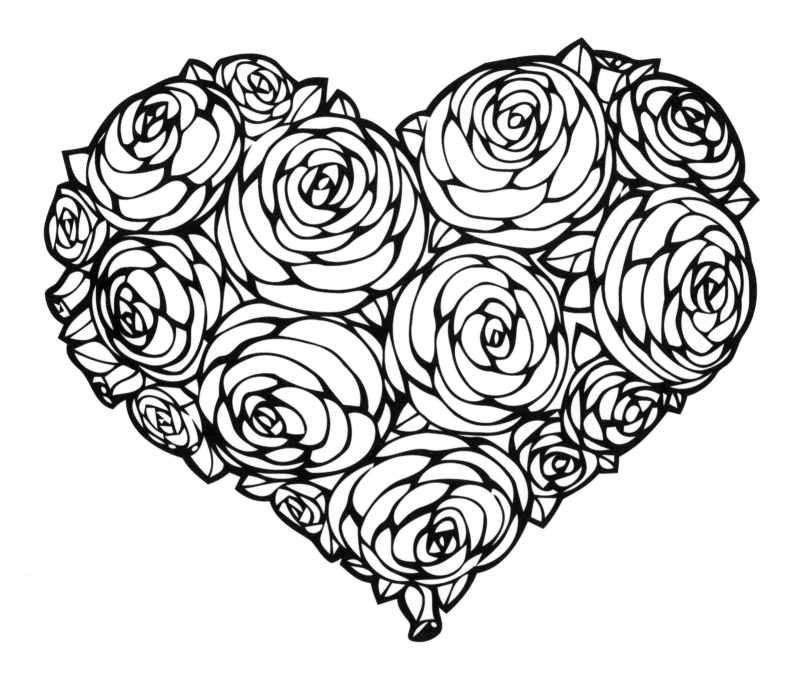

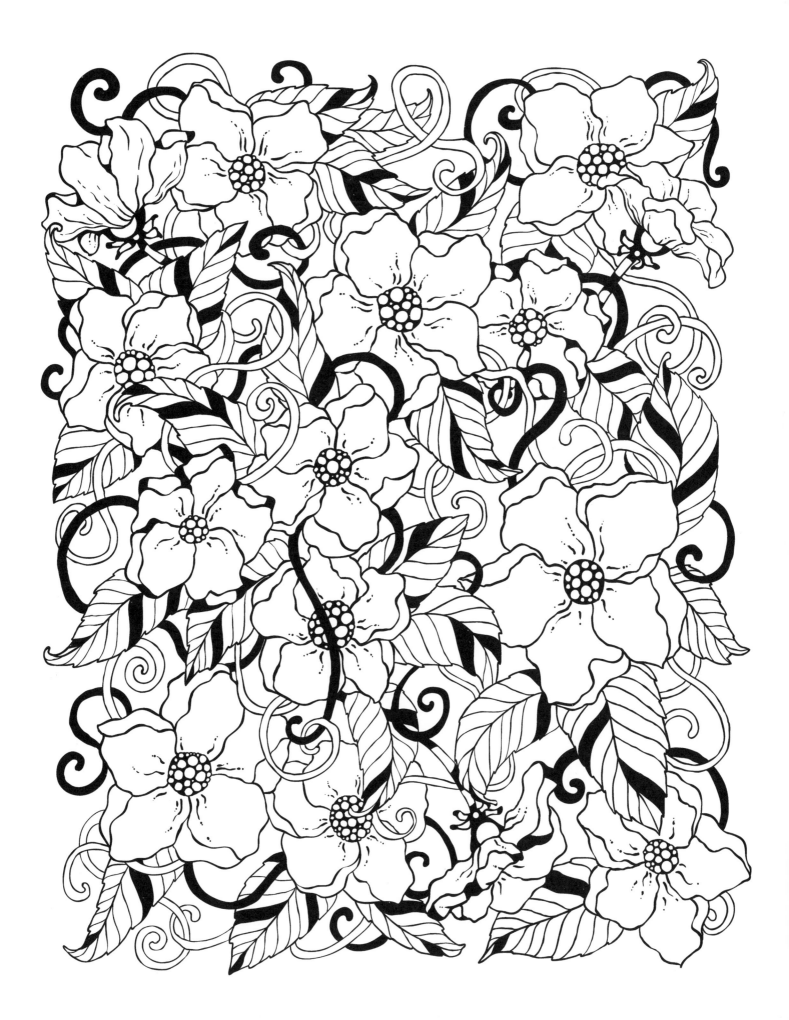

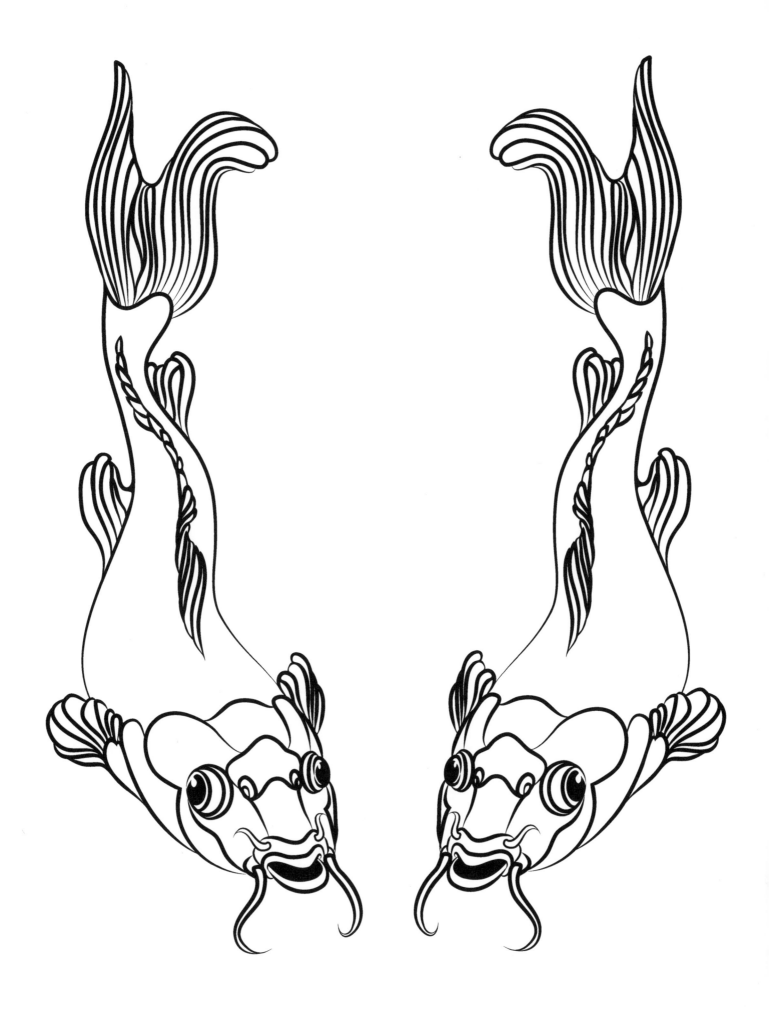

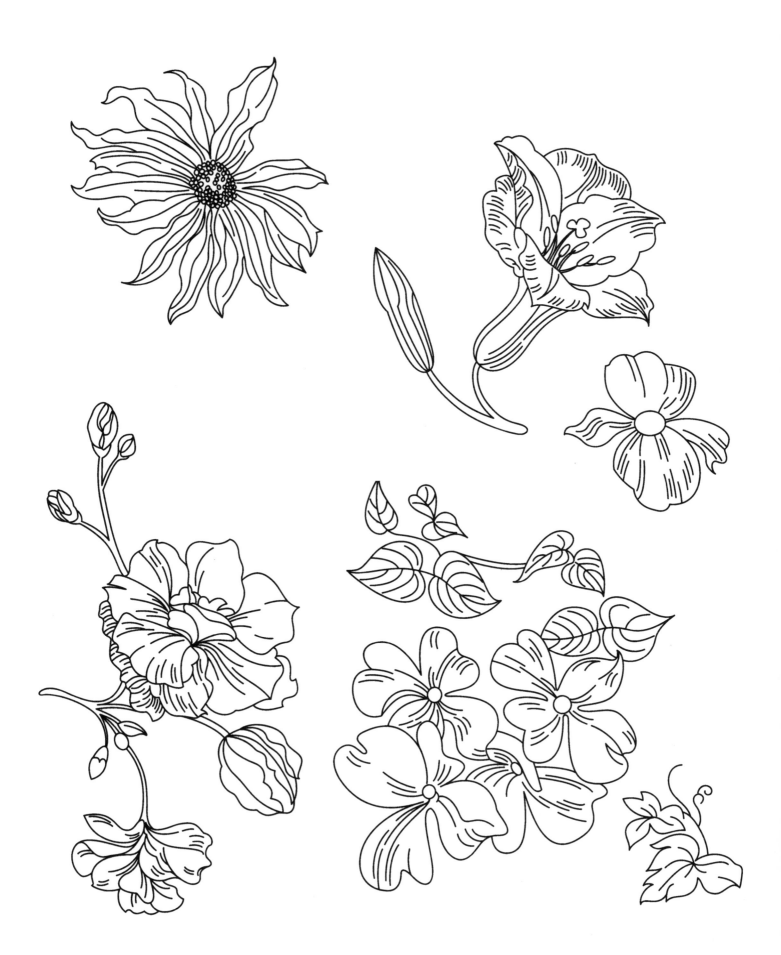

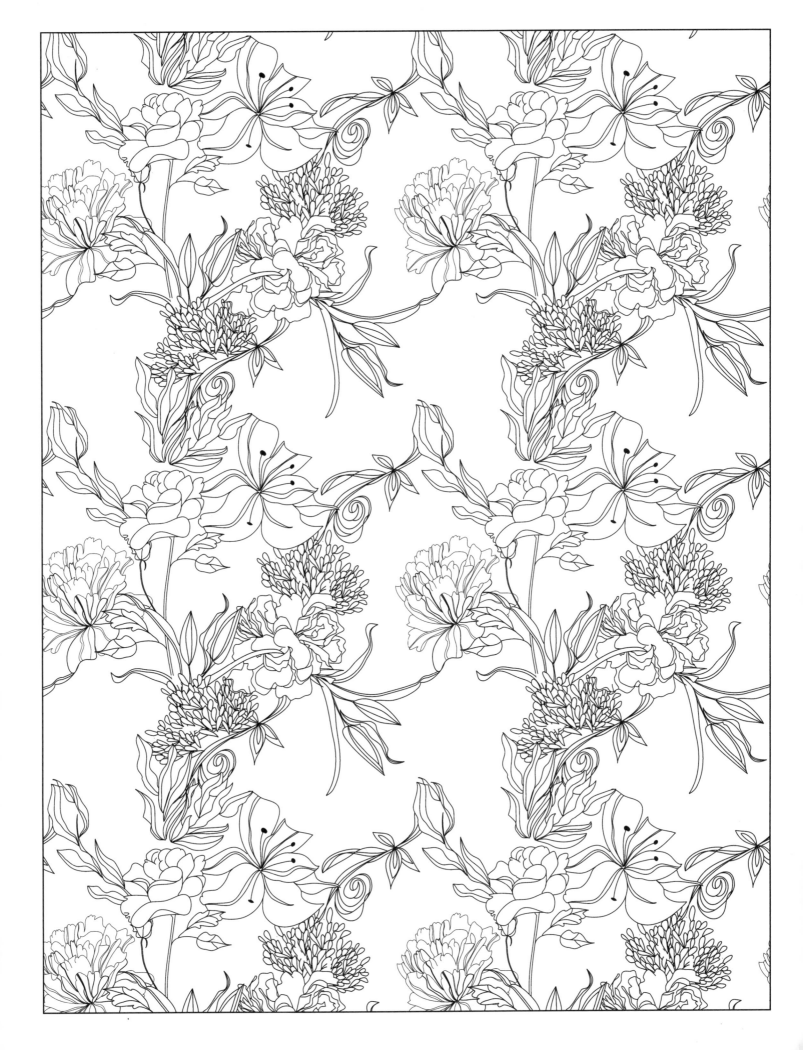

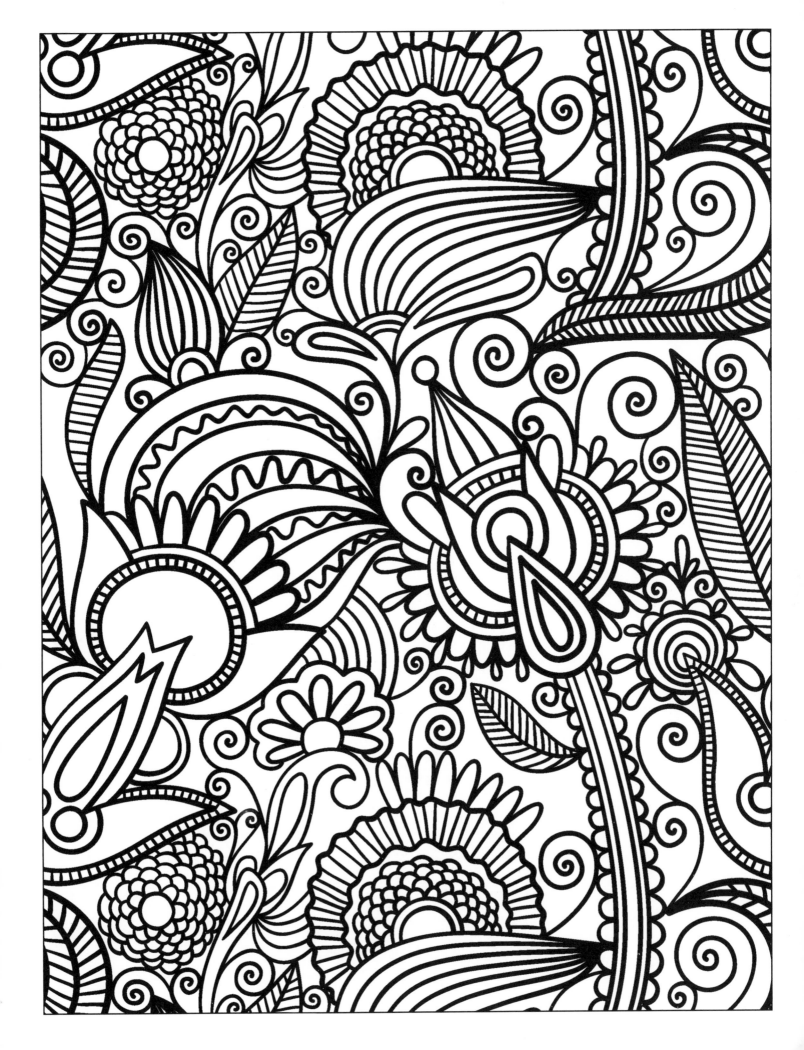

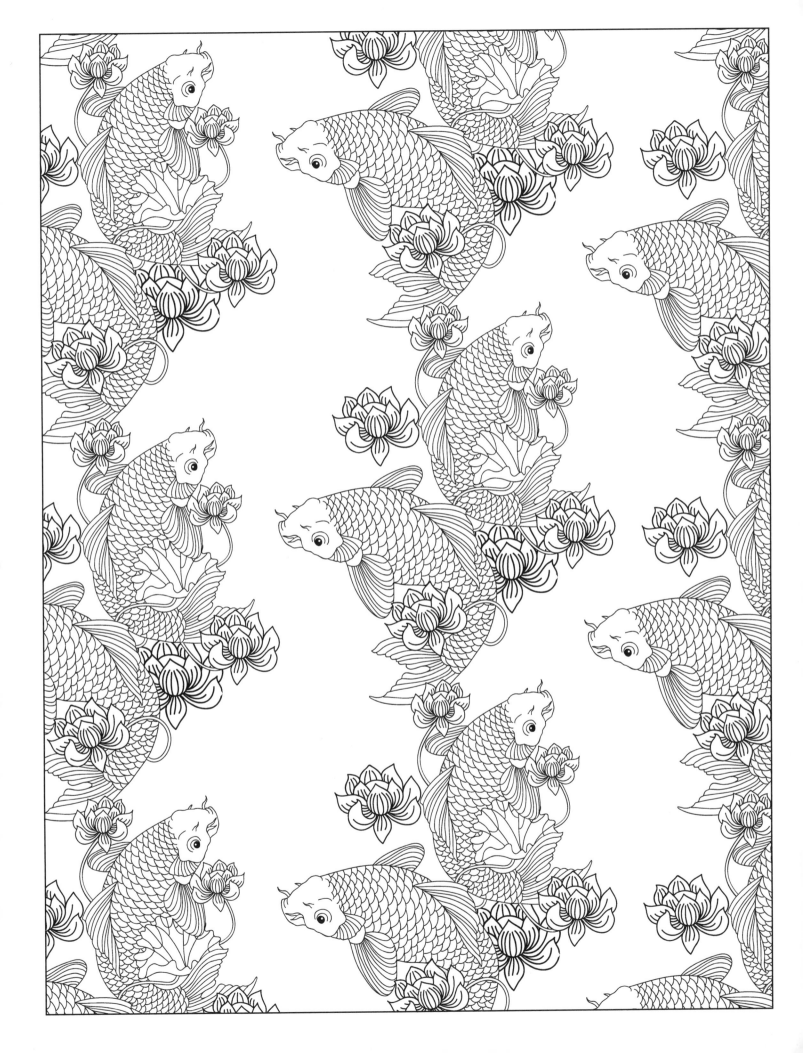

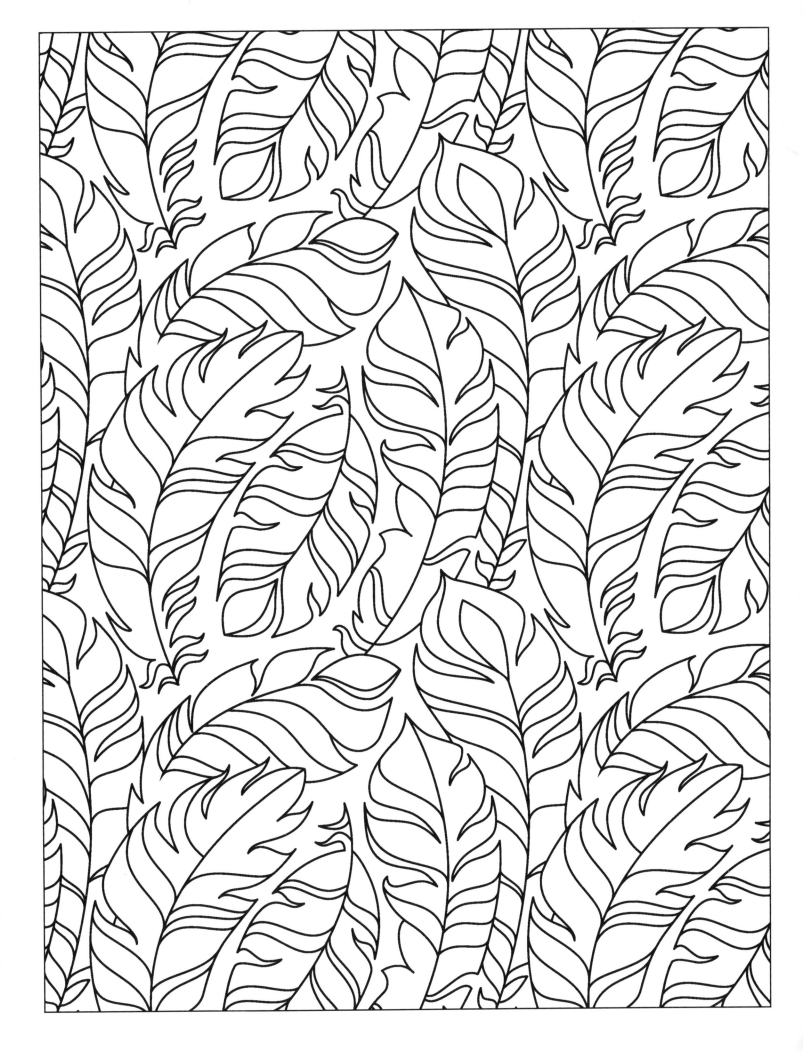

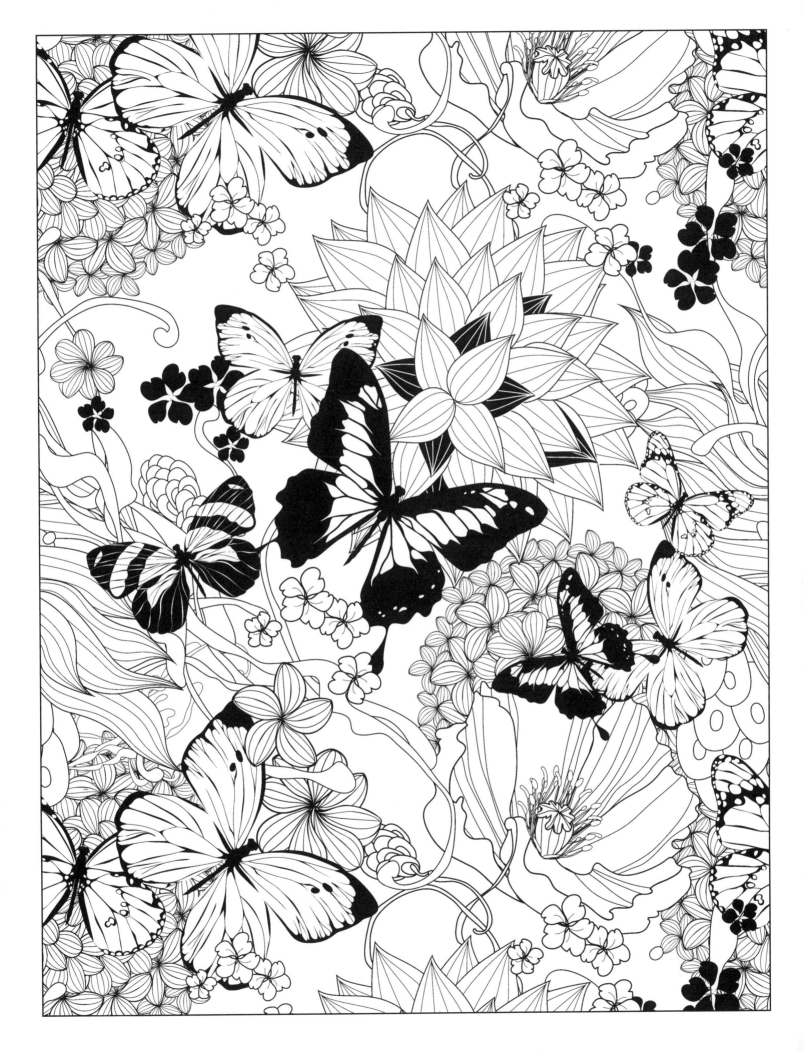

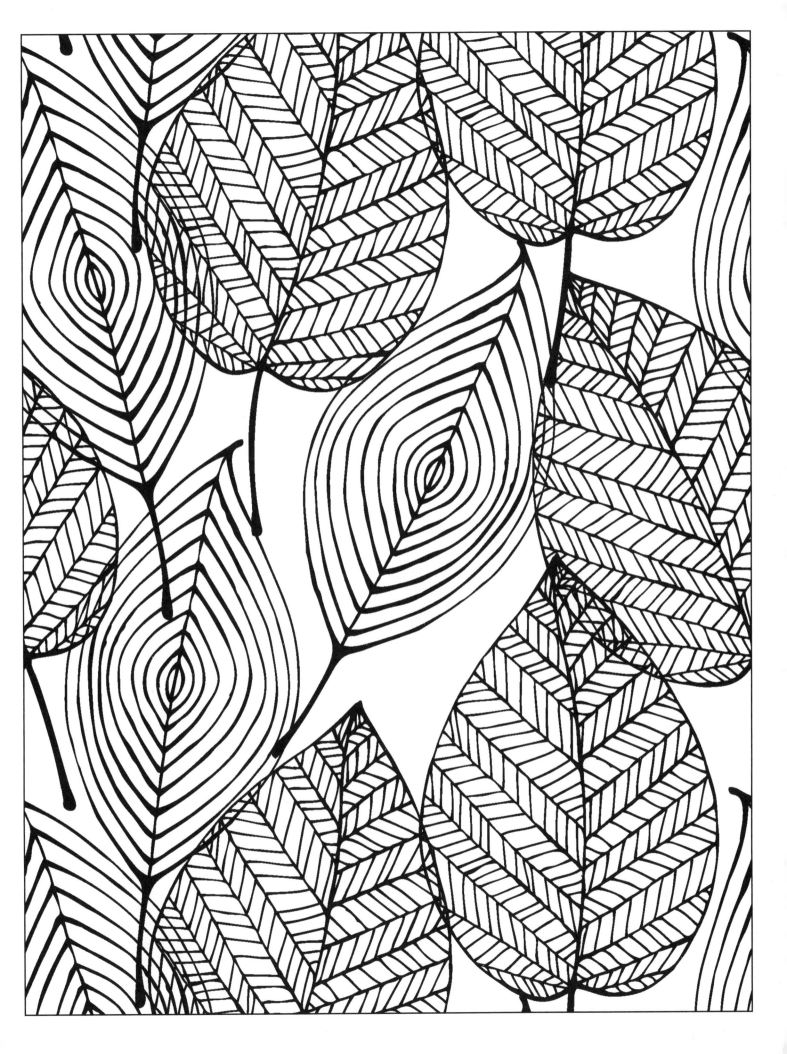